POSTCARD HISTORY SERIES

Peabody

IN VINTAGE POSTCARDS

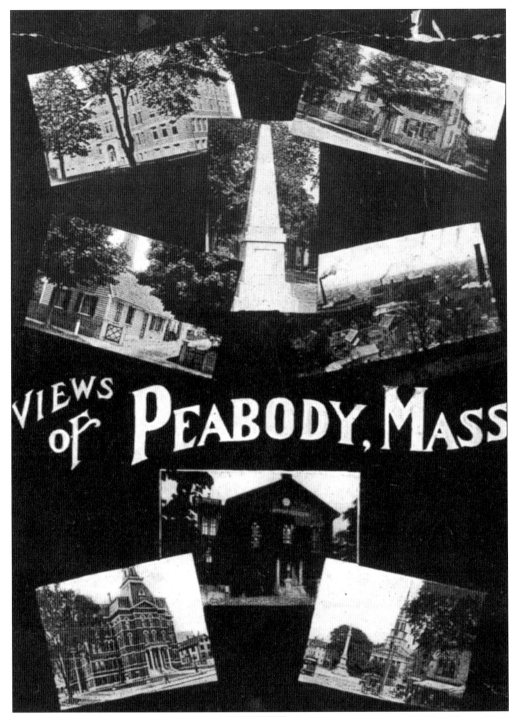

VIEWS OF PEABODY, C. 1916. This postcard (sent from Melrose to Hampton Beach, New Hampshire) shows Peabody High School, the city hall, the square, the library, the Lexington Monument, a bird's-eye view of the city, and the Nathaniel Bowditch and George Peabody Houses. (Dave Cronin collection.)

POSTCARD HISTORY SERIES

Peabody

IN VINTAGE POSTCARDS

William R. Power

ARCADIA

Published by Arcadia Publishing,
an imprint of Tempus Publishing, Inc.
2A Cumberland Street
Charleston, SC 29401

Printed in Great Britain.

Library of Congress Catalog Card Number: 2001093046

For all general information contact Arcadia Publishing at:
Telephone 843-853-2070
Fax 843-853-0044
E-Mail sales@arcadiapublishing.com

For customer service and orders:
Toll-Free 1-888-313-2665

Visit us on the Internet at http://www.arcadiapublishing.com

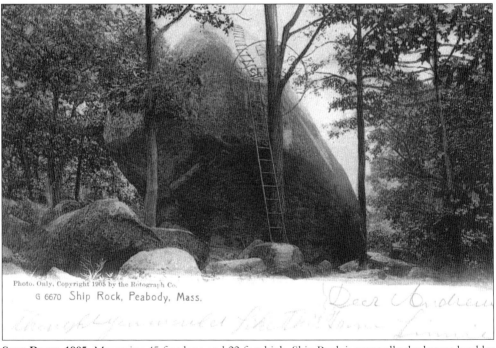

Photo. Only, Copyright 1905 by the Rotograph Co.
G 6670 Ship Rock, Peabody, Mass.

SHIP ROCK, 1905. Measuring 45 feet long and 22 feet high, Ship Rock is reputedly the largest boulder in Essex County. After using the ladder to climb to the top, one could see sweeping views of the ships in Salem Harbor. (Peabody Historical Society collection.)

CONTENTS

ACKNOWLEDGMENTS

I would like to thank Michael Schulze, Dave Cronin, Andy Metropolis, and the Peabody Historical Society and Museum for the use of their postcard collections, which made this book possible.

Thanks also go to Ann Birkner, Betty Cassidy, Campbell Soutter, and all the members of Peabody's historical community who have helped and inspired me over the years.

Of course, special thanks go to my wife, Lucy; my son Jon; and my daughter Nicole for their patience and understanding with me during the writing of this book.

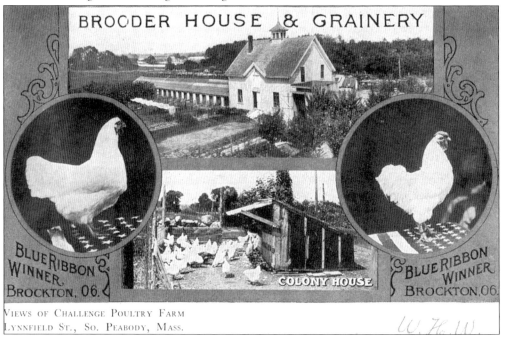

THE CHALLENGE POULTRY FARM. Located on Lynnfield Street, the Challenge Poultry Farm was one of many farms in South Peabody. The owners were obviously quite proud of the blue ribbons won by their fowl at the Brockton Fair in 1906. (Michael Schulze collection.)

INTRODUCTION

What are the origins of postcards in the United States, and when did they first capture the imagination of the American public? The answers are varied, and it seems to be impossible to mark a clear beginning. While the earliest postcards were probably variations of notes and letters, pictures first appeared on advertising cards in the mid-19th century. In the 1890s, the U.S. Post Office issued plain-front, prestamped postal cards with a price of 1¢. At the Columbian Exposition in Chicago in 1893, postal cards with scenes of the exposition on the front were being sold and required a 2¢ stamp on top of the purchase price. Postal cards had therefore become souvenirs as well as a means to send news and greetings back home. These pictures of buildings, factories, tourist sites, and scenic views showed those at home what the "here" in "wish you were here" really looked like.

Prior to 1907, the post office discouraged the writing of messages on the back, since it often times made it difficult to decipher the addressee. Notes were written on the scene in front. In 1898, the post office granted private printers the right to print and sell scenic postcards. Salesmen, illustrators, and photographers spread out far and wide to find the scenes that both businesses and the public would buy. In most of the larger cities and towns, local printers got into the postcard business by marketing local sights. Scenic postal cards were labeled "Souvenir Card" or "Mail Card." In the early 20th century, the majority of them were labeled "Post Card."

In 1906, George Eastman's Kodak Company introduced the Pocket Kodak camera, which allowed the public to have its black-and-white photographs printed on postcard stock. Many of the postcards in this book are of this personal type.

In 1907, the post office allowed the use of divided-back postcards—the same type used today, with the address on the right and the message on the left. In 1907, the public mailed some 675 million postcards. After World War I, the use of the telephone rapidly diminished the use of postcards as a means of everyday communication. Postcards became primarily collector's items or colorful souvenirs sent home from vacation.

By providing glimpses into a particular place and time, the postcards in this book serve as an invaluable photographic record. The brief messages give us an idea about the social and cultural mores of their time.

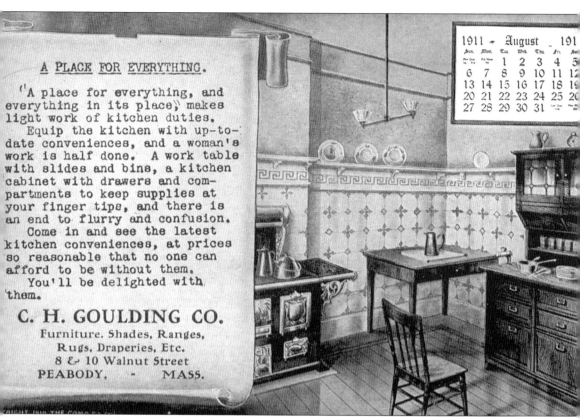

A PLACE FOR EVERYTHING.

"A place for everything, and everything in its place" makes light work of kitchen duties.

Equip the kitchen with up-to-date conveniences, and a woman's work is half done. A work table with slides and bins, a kitchen cabinet with drawers and compartments to keep supplies at your finger tips, and there is an end to flurry and confusion.

Come in and see the latest kitchen conveniences, at prices so reasonable that no one can afford to be without them.

You'll be delighted with them.

C. H. GOULDING CO.

Furniture. Shades, Ranges,
Rugs, Draperies, Etc.
8 & 10 Walnut Street
PEABODY, - MASS.

1911 - August - 191

Sun.	Mon.	Tue.	Wed.	Thu.	Fri.	Sat.
		1	2	3	4	5
6	7	8	9	10	11	12
13	14	15	16	17	18	19
20	21	22	23	24	25	26
27	28	29	30	31		

'A PLACE FOR EVERYTHING.' This advertising postcard from 1911 shows what the well-appointed kitchen of the day should look like. The C.H. Goulding furniture store was located on Walnut Street near Central. (Michael Schulze collection.)

One

THE LEGACY OF
GEORGE PEABODY

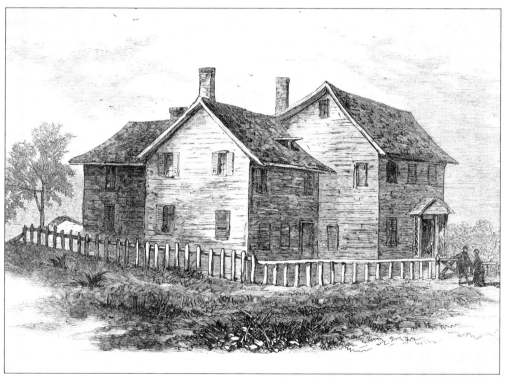

A SKETCH OF THE GEORGE PEABODY BIRTHPLACE. This early sketch shows what the birthplace of merchant, banker, and philanthropist George Peabody must have looked like in 1795, when he was born. (Dave Cronin collection.)

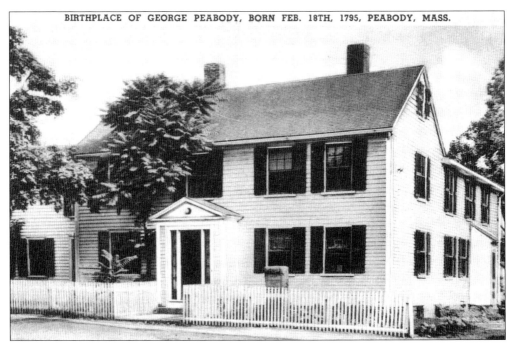

BIRTHPLACE OF GEORGE PEABODY, BORN FEB. 18TH, 1795, PEABODY, MASS.

THE BIRTHPLACE OF GEORGE PEABODY. In this early view, the Peabody home, located at 205 Washington Street, appears much the same as it does today. Now owned and operated by the city, it is known as the George Peabody Civic Center. (Michael Schulze collection.)

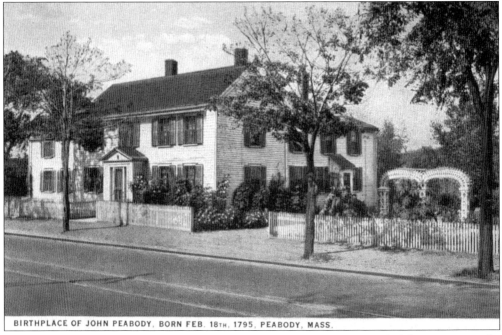

BIRTHPLACE OF JOHN PEABODY, BORN FEB. 18TH, 1795, PEABODY, MASS.

THE BIRTHPLACE OF GEORGE PEABODY, C. 1936. In this later postcard (mailed from Danvers), the grounds of the George Peabody birthplace are absolutely beautiful. However, the publisher of the card has erroneously attributed the house to John Peabody. (Michael Schulze collection.)

THE TABLET AT THE BIRTHPLACE OF GEORGE PEABODY. This bronze tablet, commemorating the birthplace of George Peabody, was placed by the Peabody Historical Society on June 18, 1902. (Peabody Historical Society collection.)

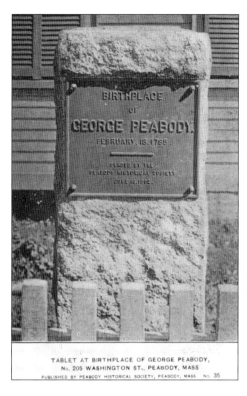

TABLET AT BIRTHPLACE OF GEORGE PEABODY,
No. 205 WASHINGTON ST., PEABODY, MASS
PUBLISHED BY PEABODY HISTORICAL SOCIETY, PEABODY, MASS NO. 35

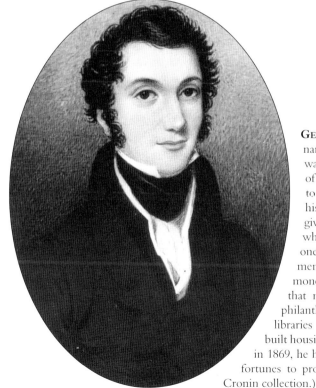

GEORGE PEABODY, C. 1830S. Peabody's namesake and its most illustrious citizen was born on February 18, 1795. At the age of 11, he quit school and was apprenticed to work in a local dry goods store. When his apprenticeship was complete, he was given a suit of clothing and set out on what was to be a meteoric rise to become one of the wealthiest and most respected men in the world. His skill at making money was legendary. His generosity with that money made him the first important philanthropist in America. He endowed many libraries and institutions of higher learning and built housing for the poor of London. By his death in 1869, he had given away one of the world's great fortunes to promote the values of education. (Dave Cronin collection.)

11

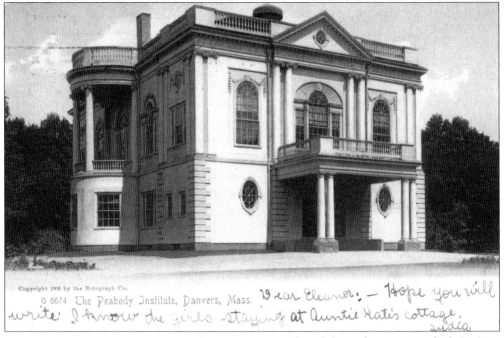

Copyright 1906 by the Rotograph Co.
G 6674 The Peabody Institute, Danvers, Mass. *Dear Eleanor: — Hope you will write. I know the girls staying at Auntie Kate's cottage. Sudie*

THE PEABODY INSTITUTE, DANVERS. This *c.* 1906 Rotograph card shows the present Peabody Institute Library of Danvers. Constructed in 1890, this building was a replacement for the original, which was built with a gift of $100,000 from George Peabody and was destroyed by fire. (Author's collection.)

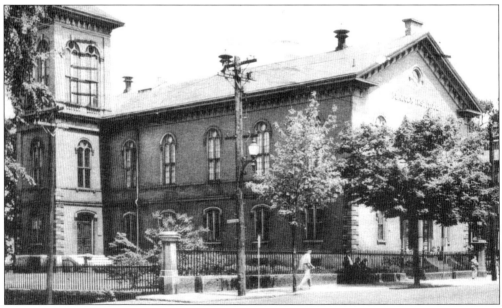

THE PEABODY INSTITUTE, PEABODY. The Peabody Institute Library is one of the most popular subjects for postcards relating to the city of Peabody. Constructed in 1852, it was the first of many libraries that George Peabody either built or endowed. The classic design of this Italian Villa–style building has helped to make a center of Peabody's architectural, cultural, and social landscape for more than 150 years. (Michael Schulze collection.)

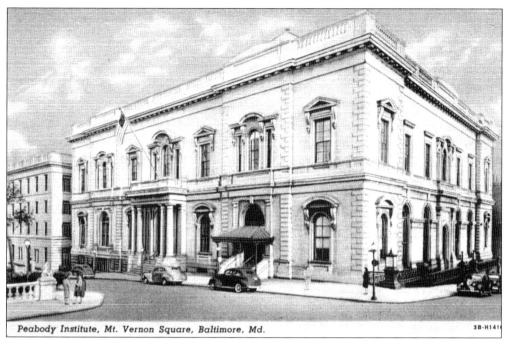

Peabody Institute, Mt. Vernon Square, Baltimore, Md.

THE PEABODY INSTITUTE OF BALTIMORE. Baltimore, Maryland, was home to George Peabody and the firm of Peabody, Riggs & Company from 1814 until he moved to London. Starting in 1857, Peabody donated a total of $1.4 million to establish the Peabody Institute of Baltimore. The institute included an art museum, library, and music academy—all of which are active today. (Author's collection.)

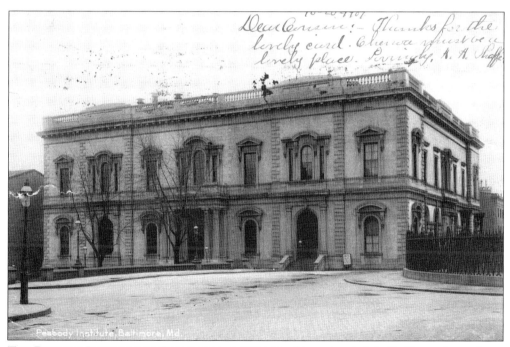

THE PEABODY INSTITUTE OF BALTIMORE, C. 1907. On this postcard, A.A. Shaffer sends word to a cousin, Ella Evans, of Chenoa, Illinois. (Author's collection.)

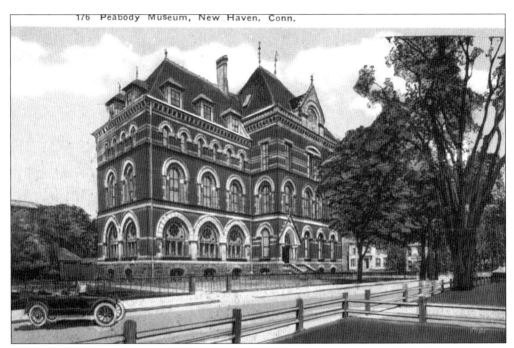

THE PEABODY MUSEUM, YALE UNIVERSITY. In 1866, George Peabody donated $150,000 to fund a museum and professorial chair in paleontology. This was the first such professorship in America. (Author's collection.)

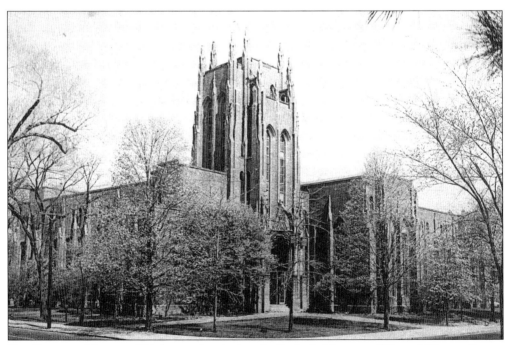

THE PEABODY MUSEUM. This is a modern look at the Peabody Museum of Natural History. George Peabody's generous gifts to Yale and Harvard helped establish science as an acceptable course of study in what were predominately arts-and-letters institutions. (Author's collection.)

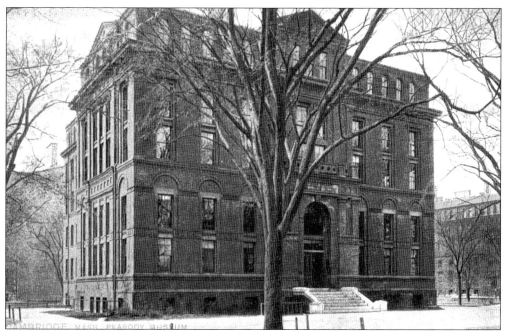

THE PEABODY MUSEUM, CAMBRIDGE. In 1866, George Peabody donated $150,000 to Harvard College to establish an endowment for a professorship in anthropology and to construct a fireproof museum to house part of Harvard's vast archeological collections. (Author's collection.)

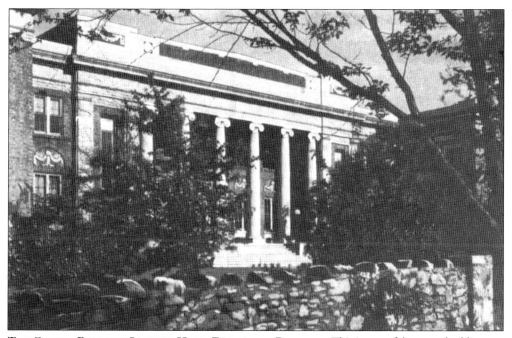

THE GEORGE PEABODY COLLEGE HOME ECONOMICS BUILDING. This is one of the many buildings on the campus of the George Peabody College for Teachers in Nashville, Tennessee. (Author's collection.)

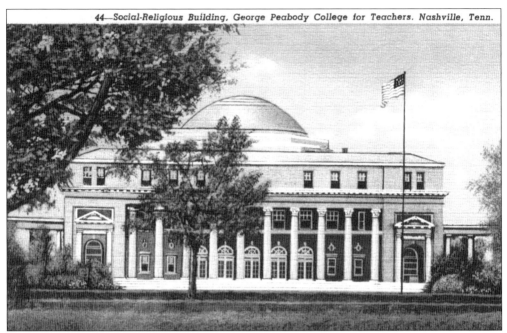

THE GEORGE PEABODY COLLEGE FOR TEACHERS, NASHVILLE, TENNESSEE. Founded in 1875 as the Peabody Normal College, the school was officially renamed George Peabody College for Teachers in 1908. It is now part of Vanderbilt University. (Author's collection.)

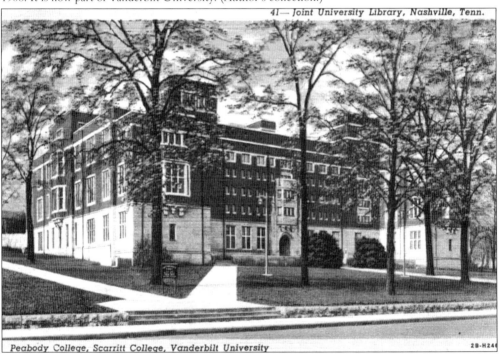

Peabody College, Scarritt College, Vanderbilt University

2B-H24

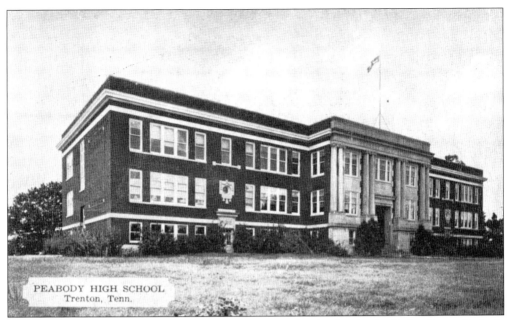

PEABODY HIGH SCHOOL, TRENTON, TENNESSEE, 1935. Shortly after the Civil War, George Peabody donated more than $2 million to establish the Southern Education Fund. The purpose of the fund was to help in the restoration of the educational system in the South, decimated by the war. There were many elementary and secondary schools constructed with these funds. The high school in Trenton, Tennessee, is one such school. (Author's collection.)

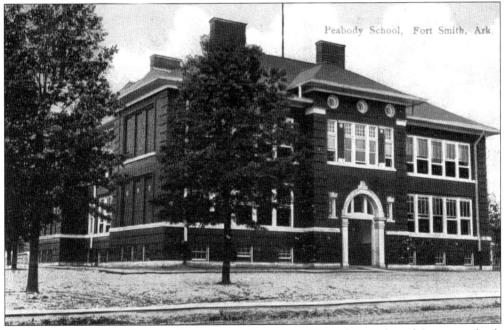

THE GEORGE PEABODY SCHOOL, FORT SMITH, ARKANSAS. Pictured is another of the many schools named for George Peabody in the United States. Other schools that bear his name include those in San Francisco, California; Dallas, Texas; Washington, D.C.; Memphis, Tennessee; Petersburg, Virginia; and St. Louis, Missouri. (Author's collection.)

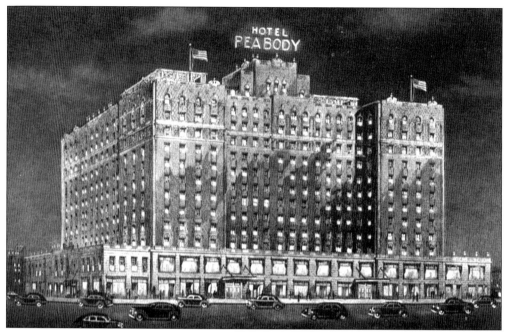

THE HOTEL PEABODY, MEMPHIS, TENNESSEE. The Hotel Peabody was built in 1869 by Robert Campbell Brinkley, a friend of George Peabody. It was rebuilt in 1925 and is renowned for its elegant lobby, fountain, and the daily parade of ducks from the elevator to that fountain. There is now a grand Hotel Peabody in Orlando, Florida, as well. (Author's collection.)

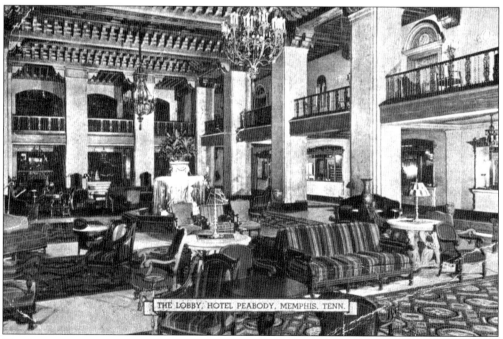

THE HOTEL PEABODY LOBBY. The back of this card reads, "Summer and winter air conditioned . . . surrounded by shops and facilities to meet the requirement of any guest." (Author's collection.)

GEORGE PEABODY, 1866. This postcard depicts George Peabody at the age of 71, just three years before his death. (Peabody Historical Society collection.)

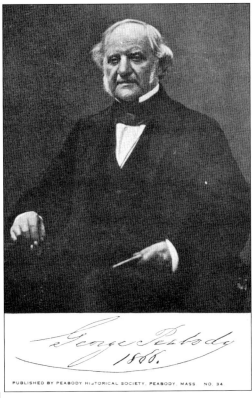

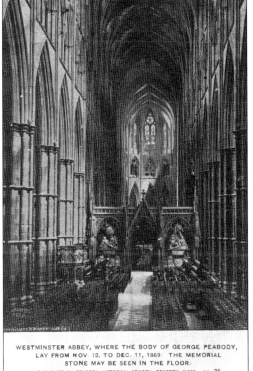

WESTMINSTER ABBEY, WHERE THE BODY OF GEORGE PEABODY, LAY FROM NOV. 12. TO DEC. 11, 1869. THE MEMORIAL STONE MAY BE SEEN IN THE FLOOR.

WESTMINSTER ABBEY. George Peabody died in London on November 4, 1869. A funeral was held on November 11 at Westminster Abbey, the final resting place of England's kings and queens. Although he was interred at Westminster for only a month, his granite marker can still be seen there today. (Peabody Historical Society collection.)

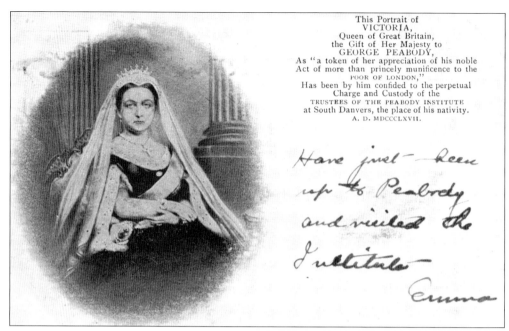

This Portrait of
VICTORIA,
Queen of Great Britain,
the Gift of Her Majesty to
GEORGE PEABODY,
As "a token of her appreciation of his noble
Act of more than princely munificence to the
POOR OF LONDON,"
Has been by him confided to the perpetual
Charge and Custody of the
TRUSTEES OF THE PEABODY INSTITUTE
at South Danvers, the place of his nativity.
A. D. MDCCCLXVII.

Have just been up to Peabody and visited the Institute — Emma

A Porcelain Miniature of Queen Victoria. In 1867, Queen Victoria commissioned a porcelain miniature portrait of herself to be given to George Peabody. This commission was in acknowledgment of Peabody's "act of princely munificence to the Poor of London." In 1862, Peabody gave the first of many gifts to the Peabody Donation Fund, which eventually totaled $2.5 million. This money was to be used to build housing for London's poor. This fund has grown today to be valued at nearly $600 million, with more than 8,000 apartments having been built. (Michael Schulze collection.)

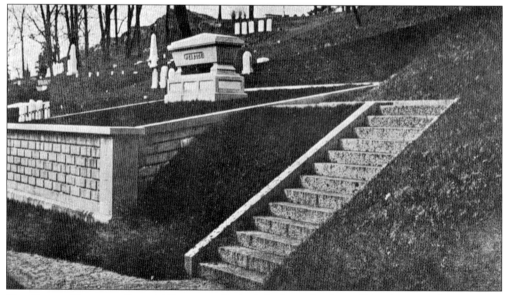

The Burial Place of George Peabody. Peabody had stated in his will that he wanted to be buried in the town that had adopted his name. With much pomp and ceremony, he was moved from his grave at Westminster Abbey to this site in Harmony Grove Cemetery in February 1870. The tomb and the surrounding area have recently been restored. (Peabody Historical Society collection.)

Two
STREETSCAPES
AND SQUARES

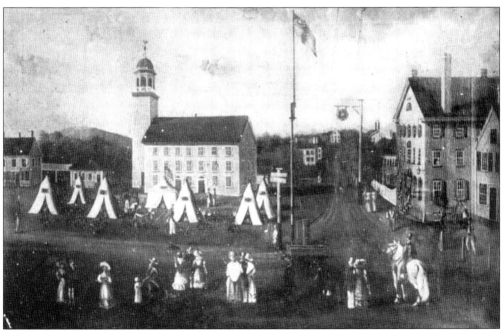

PEABODY SQUARE, 1828. In this painting, the new Dustin Hotel and Henry Poor's house are on the right. In the middle (in front of the South Congregational Church) is an encampment of the Danvers Light Infantry under the command of William Sutton. (Peabody Historical Society collection.)

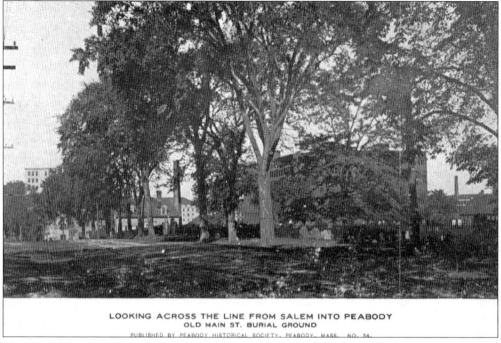

LOOKING ACROSS THE LINE FROM SALEM INTO PEABODY
OLD MAIN ST. BURIAL GROUND
PUBLISHED BY PEABODY HISTORICAL SOCIETY, PEABODY, MASS. NO. 54.

MAIN STREET ON THE SALEM-PEABODY LINE. This is the site of the Old South Cemetery, the oldest-known burial ground in the city of Peabody. Also called the Old Main Street (or Trask) Burial Ground, it dates from at least 1683. Also visible next to the cemetery is the second schoolhouse in the city, District No. 1. (Peabody Historical Society collection.)

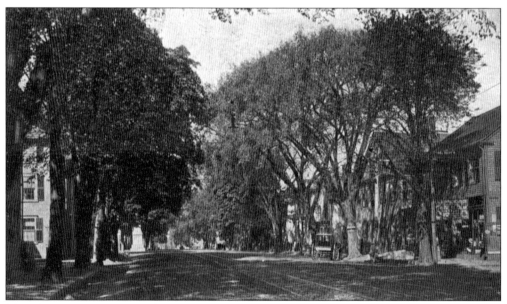

MAIN STREET, PEABODY. Looking west toward the square, we see 111 Main Street on the immediate left and the base of the Lexington Monument. On the right, a sign in front of the D'Entremont & Company store reads, "Peerless Ice Cream, 100% Pure." (Peabody Historical Society collection.)

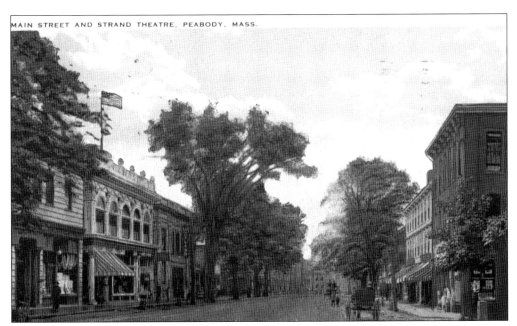

MAIN STREET, PEABODY, C. 1923. In yet another perspective of Main Street, we see the Strand Theatre on the left. On the immediate right, across Wallis Street from the library, is the Sutton Block. A wagon and what appears to be a truck are in sight on the left. Maybe the truck is one of Peabody's own Coulthard Steam Trucks, manufactured by the Corwin Company of South Peabody about a decade before this postcard was made. (Michael Schulze collection.)

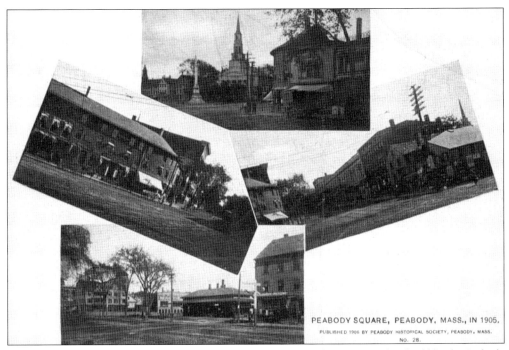

PEABODY SQUARE, PEABODY, MASS., IN 1905.
PUBLISHED 1906 BY PEABODY HISTORICAL SOCIETY, PEABODY, MASS.
NO. 28.

FOUR VIEWS OF PEABODY SQUARE, C. 1905. This postcard, one of many printed and sold by the Peabody Historical Society, shows four different perspectives of the square. (Peabody Historical Society collection.)

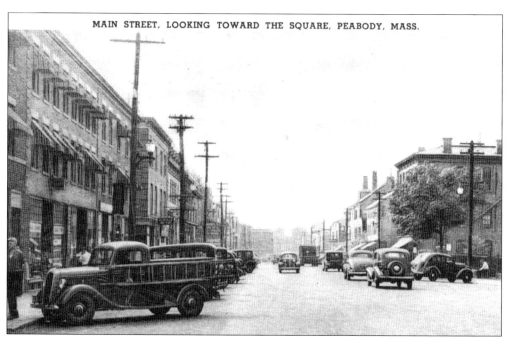

MAIN STREET, LOOKING TOWARD THE SQUARE, PEABODY, MASS.

MAIN STREET, LOOKING TOWARD THE SQUARE, PEABODY. In another view from the early 1940s, we see a sign proclaiming, "Genesee on Tap." The movie *Twelve Hours* is playing at the Strand Theatre. Sitting on the wall in front of the library, two men are enjoying the weather and their conversation. (Michael Schulze collection.)

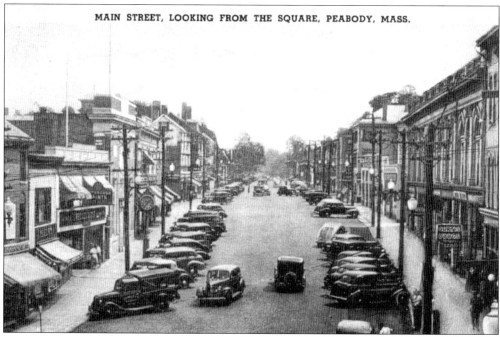

MAIN STREET, LOOKING FROM THE SQUARE, PEABODY, MASS.

MAIN STREET FROM THE SQUARE. A grocery delivery truck is first in line in this postcard, mailed in 1942. Two people look in the window of Whidden's Hardware a bit farther up the street. On the right is a First National grocery store. (Michael Schulze collection.)

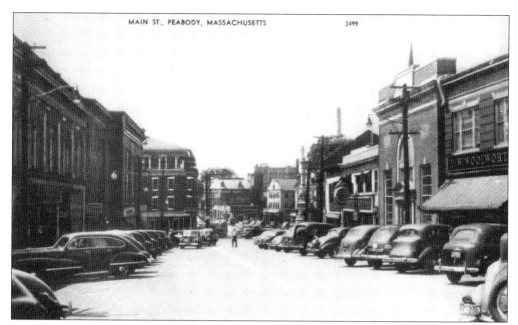

MAIN STREET, PEABODY. This view, looking west toward Peabody Square, appears to have been taken in the 1940s. On the left are Curtis Drug and S.S. Kresge's, and on the right is F.W. Woolworth. (Michael Schulze collection.)

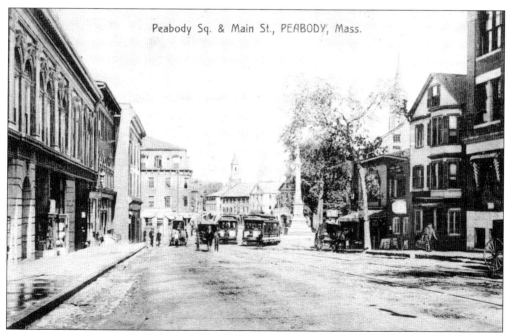

Peabody Sq. & Main St., PEABODY, Mass.

PEABODY SQUARE, C. 1900. The building on the left houses Manning's Lunch (previously on the corner of Foster Street and the square). An ice-delivery wagon is approaching Manning's Lunch. A streetcar on its way to Lynn passes by the Civil War Soldiers and Sailors Monument. Another delivery wagon sits in front of the South Congregational Church. It appears to be 8:00 a.m. on a late-spring or early-summer day. There are no cars in sight yet. (Peabody Historical Society collection.)

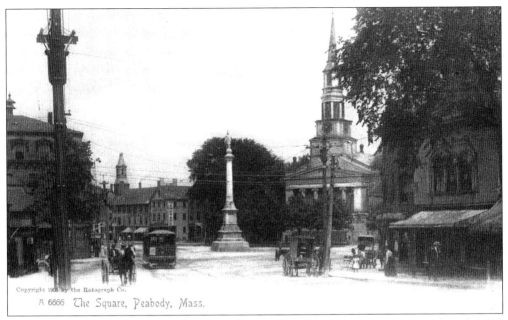

Copyright 1905 by the Rotograph Co.

A 6666 The Square, Peabody, Mass.

PEABODY SQUARE. This picture was taken from a vantage point farther up Main Street than the view on the previous page. The clock in the church tower reads 10:05. (Author's collection.)

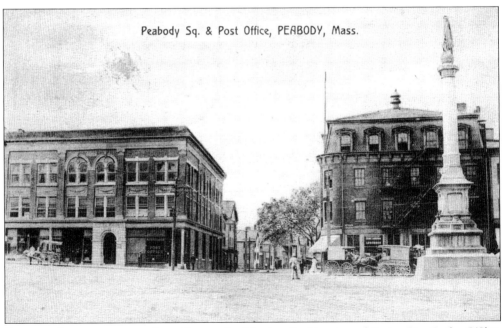

Peabody Sq. & Post Office, PEABODY, Mass.

PEABODY SQUARE AND THE POST OFFICE. In this view (looking toward Foster Street), the O'Shea Building No. 2 is now on the left. The Peabody post office is on the ground level. Manning's Lunch, on the right, advertises home cooking. (Michael Schulze collection.)

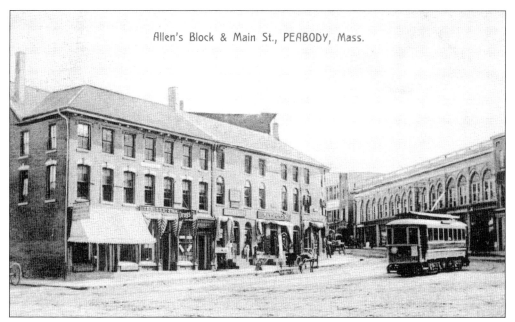

Allen's Block & Main St., PEABODY, Mass.

PEABODY SQUARE. This great postcard is filled with interesting sights. A trolley is coming through the square, and wagons are parked on Main Street. In the center is the Allen Hotel, housing the Lee Pharmacy, Farrington's Insurance, and Raymond's Pharmacy. (Michael Schulze collection.)

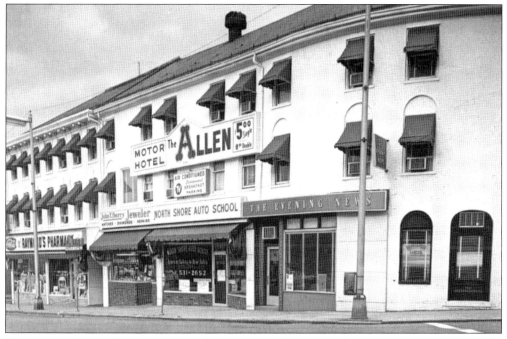

THE ALLEN MOTOR HOTEL. Contrast this view from the 1970s with the previous view. Raymond's Pharmacy is still visible but has moved to the end of the block. (Michael Schulze collection.)

27

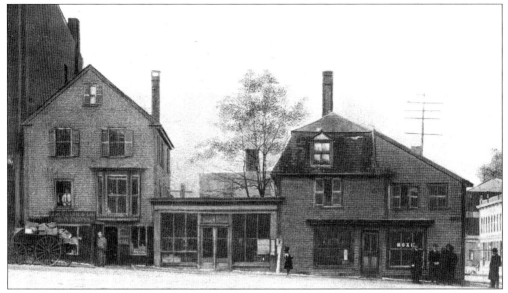

PEABODY SQUARE AND FOSTER STREET. In this early view, Foster Street seems deserted compared to the busy corner it is today. A group of men is engaged in conversation on the right. A little girl looks in their direction while a man gazes out the window of the J.W. Trask & Company at a wagonload of provisions. The house on the left is the birthplace of Gen. Gideon Foster, Peabody's Revolutionary War hero. It was torn down in 1906 to make way for the O'Shea Building No. 2, which occupies this spot today. (Dave Cronin collection.)

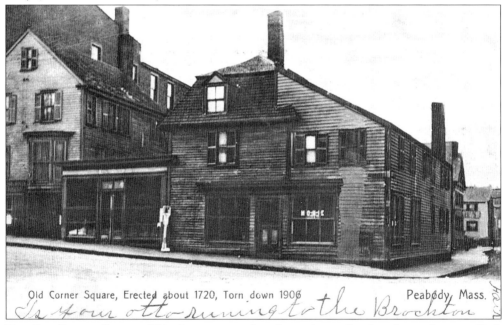

Old Corner Square, Erected about 1720, Torn down 1906 Peabody, Mass.

THE OLD CORNER SQUARE. This view appears to have been taken earlier than the previous one. Both images show an advertisement for the tonic Moxie in the window. Here, however, there is no evidence of the telephone-electric poles in the first view. The postcard was sent from Beverly to the office of United Shoe Machinery in Lynn in 1907. It was printed in Germany (as were many postcards of this era) for H.E. Raymond of Peabody. (Michael Schulze collection.)

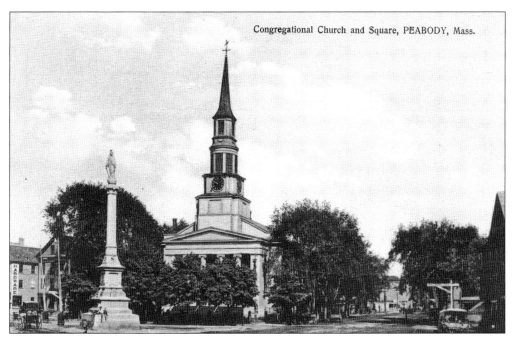

THE CONGREGATIONAL CHURCH AND SQUARE, PEABODY. The Greek Revival–style South Congregational Church was built in 1844. Note the boys playing on the monument. By the rail crossing on Lowell Street, another child runs in front of a delivery wagon. (Michael Schulze collection.)

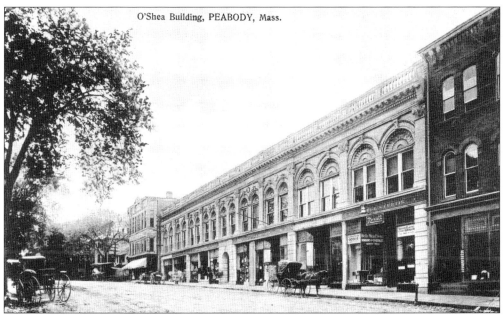

O'Shea Building, PEABODY, Mass.

THE O'SHEA BUILDING, PEABODY. The O'Shea Building No. 1 was built in 1903. On the lower level, the George S. Curtis Rexall Pharmacy advertises trusses and elastic stockings. Also available are Belle Mead Sweet Bonbons & Chocolates. Next door is Bresnahan's Paint & Wallpaper store. A little farther down the street, there is a sign for a bakery. This card was mailed in 1911. (Michael Schulze collection.)

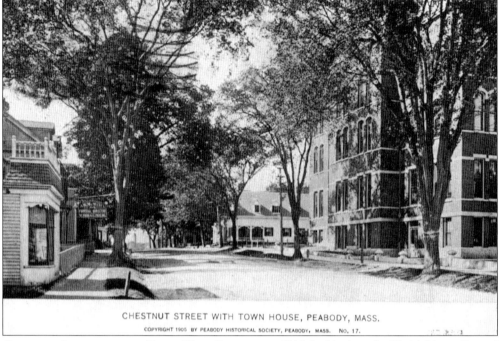

CHESTNUT STREET WITH TOWN HOUSE, PEABODY, MASS.

COPYRIGHT 1905 BY PEABODY HISTORICAL SOCIETY, PEABODY, MASS. NO. 17.

CHESTNUT STREET AND THE TOWN HALL, PEABODY, C. 1905. In this view, the J.R. McManus Funeral Parlor sign is on the left. The town hall, which would become the city hall in 1917, is partially visible on the right. The house in the center is now the home of the Peabody Municipal Credit Union. (Michael Schulze collection.)

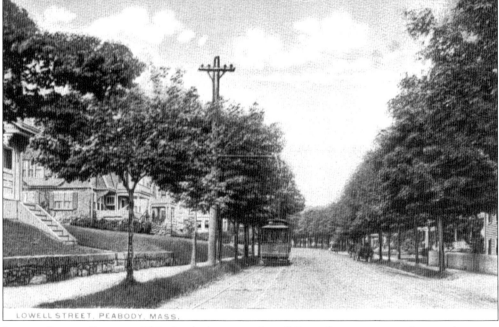

LOWELL STREET, PEABODY, MASS.

LOWELL STREET, PEABODY. This view looks west up Lowell Street from a vantage point near the corner of Endicott Street. The Southwick House, built in 1660, is visible on the right. A streetcar is heading east toward the square. (Michael Schulze collection.)

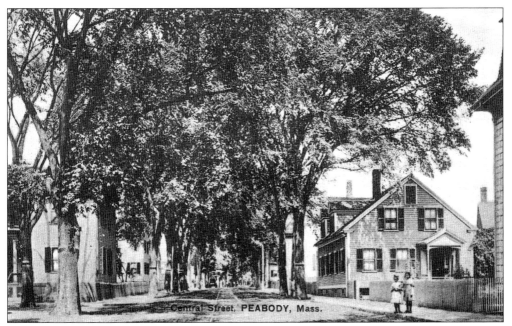

CENTRAL STREET, PEABODY. In this view, two girls stand gazing at us. The card was sent on October 25, 1908, from Mary to her aunt Ella Whipple, in Hiram, Maine. Mary speaks excitedly of an upcoming "county torchlight parade." The Whipples once lived on Central Street. (Michael Schulze collection.)

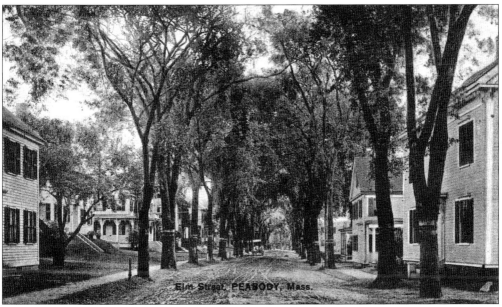

ELM STREET. This view of Elm Street appears to be from the same era as the previous postcard. Note the delivery wagon, complete with a team of white horses. There appears to be something else in the street in the same area as the wagon—a small dog perhaps. The third house on the left is the H.B. Ward estate, a magnificent Italianate Villa–style home, complete with more recent gingerbread Gothic embellishments. Mrs. George P. Beckett of 8 Elm Street sent this card to her friend in Roslindale *c.* 1911. (Peabody Historical Society collection.)

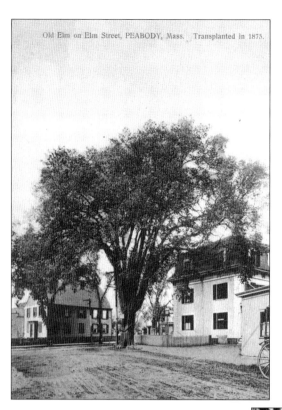

Old Elm on Elm Street, PEABODY, Mass. Transplanted in 1875.

AN OLD ELM ON ELM STREET. Looking toward Central Street, we can see that the road is not paved. The postcard tells us that this elm was transplanted to this site in 1875. Like most of the thousands of Elm Streets across America, there are few elms left on the street due to the deadly Dutch elm disease. (Peabody Historical Society collection.)

ELM STREET AND THE GATEWAY TO MONUMENTAL CEMETERY. This street of beautiful houses under a canopy of great elm trees was home to some of Peabody's most prominent citizens. John Bushby transplanted one such elm (in the foreground) to this site in 1785. Founded in 1832, the Monumental Cemetery (at the end of the street) was the preeminent burial place in the city until the dedication of the Cedar Grove Cemetery in 1869. (Peabody Historical Society collection.)

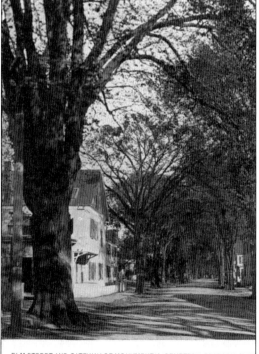

ELM STREET AND GATEWAY OF MONUMENTAL CEMETERY, PEABODY, MASS
GREAT ELM TRANSPLANTED 1785 BY JOHN BUSHBY.
COPYRIGHT 1905 BY PEABODY HISTORICAL SOCIETY, PEABODY, MASS. NO. 18.

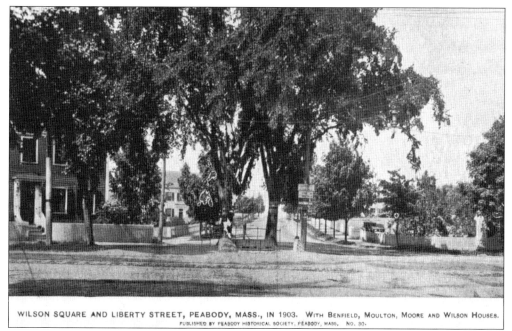

WILSON SQUARE AND LIBERTY STREET, PEABODY, MASS., IN 1903. WITH BENFIELD, MOULTON, MOORE AND WILSON HOUSES.
PUBLISHED BY PEABODY HISTORICAL SOCIETY, PEABODY, MASS. NO. 30.

WILSON SQUARE. Named after a prominent family who owned many homes in the area, Wilson Square is shown in a view from 1903. Andover Street runs across the bottom of the photograph. To the left is Middleton, and to the right is Peabody Square. Liberty Street, now called Pulaski Street, heads straight ahead toward Danversport. Note the horse trough beneath the trees. (Michael Schulze collection.)

WILSON SQUARE, 1903. In this view of Wilson Square, note the boys at play. Perhaps they are playing marbles or mumblety-peg. (Michael Schulze collection.)

33

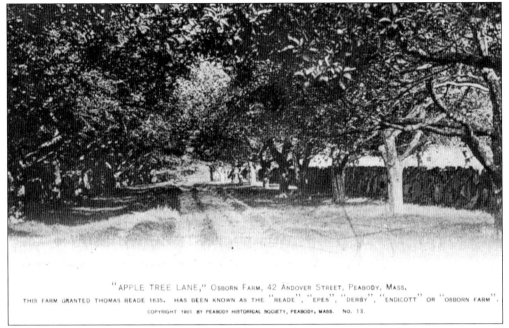

APPLE TREE LANE. This old street, currently called Buttonwood Lane, was the site of a large farm started in 1635. At various times, it was owned by the Read, Epes, Derby, and Endicott families. At the time this picture was taken *c.* 1905, it was known as the Osborn Farm. (Peabody Historical Society collection.)

PROSPECT STREET. Prospect Street runs from present-day Su Chang's to Felton's Corner and Andover Street. The Northshore Mall now occupies the area to the right. (Peabody Historical Society collection.)

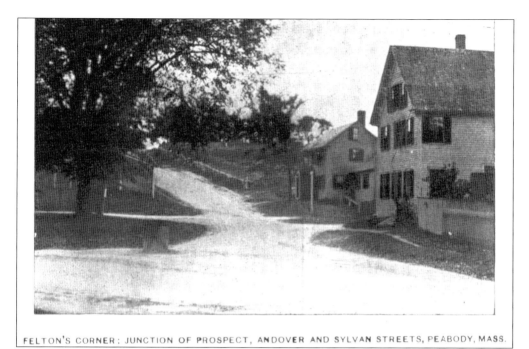

FELTON'S CORNER: JUNCTION OF PROSPECT, ANDOVER AND SYLVAN STREETS, PEABODY, MASS.

FELTON'S CORNER. Felton's Corner, or Feltonville, was located at the junction of Prospect Street, Sylvan Street, and Route 114. Looking up Prospect Street toward the mall, we see the Felton Cemetery on the right. The houses on the right are the country store and offices of Nathan Felton, town clerk. While the cemetery is still in existence, D'Angelo's and Speedee Oil Change now stand on this site. (Peabody Historical Society collection.)

THE TRIANGLE AT FELTON'S CORNER. This view looks north on Andover Street (Route 114) toward Lawrence. The street on the right is Sylvan Street. Today, Just For Pets is on this corner. To the left is Prospect Street. (Peabody Historical Society collection.)

FOREST STREET, WEST PEABODY. This early view of Forest Street predates the Salem Country Club. There are a number of wagon tracks visible on the unpaved dirt road. George Marsh's house is visible on the left. The Marsh property went all the way back to Lowell Street and is now the site of the Rolling Hills subdivision. There were three Marsh cemeteries scattered over the large property. All have since disappeared. Another, the Marsh Tomb, can still be seen on the corner of Summit Street and Centennial Drive. (Peabody Historical Society collection.)

Three

PUBLIC BUILDINGS
AND CHURCHES

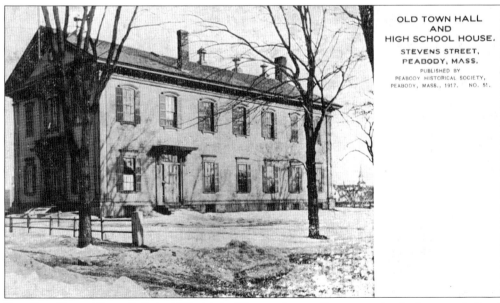

OLD TOWN HALL
AND
HIGH SCHOOL HOUSE.

STEVENS STREET,
PEABODY, MASS.
PUBLISHED BY
PEABODY HISTORICAL SOCIETY,
PEABODY, MASS., 1917. NO. 51.

THE OLD TOWN HALL. Built in 1855, this building on Stevens Street served as both a town hall and high school. When the new town hall was built in 1883, this building became Peabody High School and remained so until 1904. It is currently in use as the Veterans of Foreign Wars hall. (Peabody Historical Society collection.)

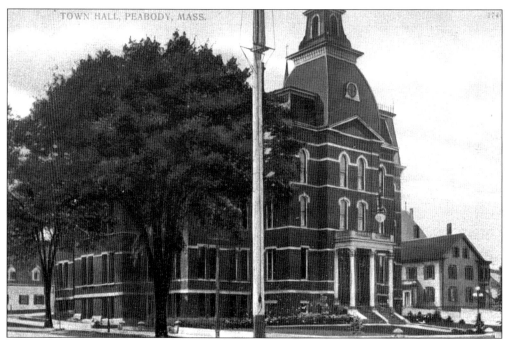

THE PEABODY TOWN HALL. Built in 1883, this building is Peabody's second town hall. The architect for this Second Empire–style edifice was Rufus Sargent of Newburyport. The property, which still serves as Peabody's city hall, is listed on the National Register of Historic Places. (Peabody Historical Society collection.)

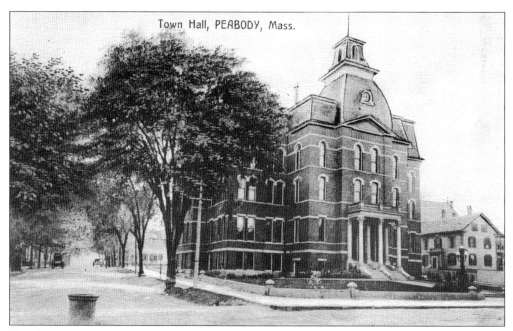

THE PEABODY TOWN HALL. In this view of the town hall, we see that the building has changed little in over 120 years. Chestnut Street is on the left. The house on the right is now used as the Cahill-Brodeur Funeral Home. (Michael Schulze collection.)

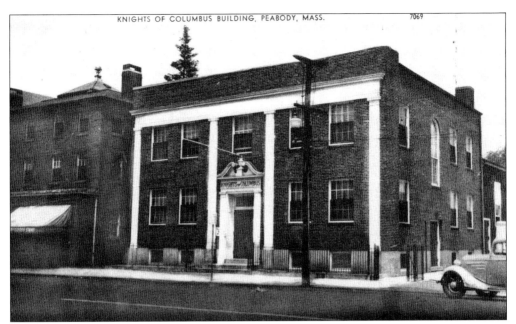

THE KNIGHTS OF COLUMBUS BUILDING, PEABODY. Hosting political rallies, weddings, Bingo, Girl Scout dances, showers, and ballroom dancing, this is one of the busiest halls in Peabody. (Dave Cronin collection.)

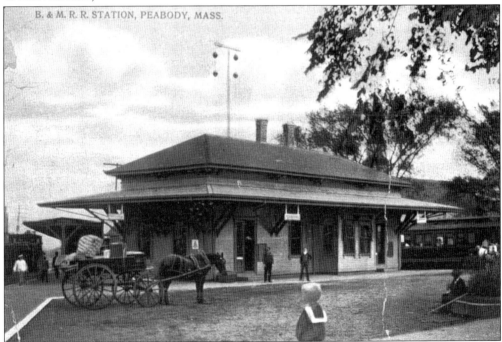

THE BOSTON & MAINE STATION. The central train station was located on the corner of Walnut and Central Streets. In this early view, we see lots of activity—all of it being watched by the boy in the sailor suit in the foreground. On the left is a freight train. On the right, passengers board a train. A horse hitched to a wagon of goods waits patiently for his driver. A man sits on the curb with his cane lying beside him. (Peabody Historical Society collection.)

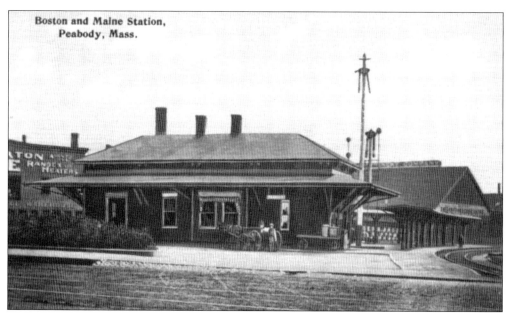

Boston and Maine Station,
Peabody, Mass.

THE MAIN RAILROAD STATION. The train station was the city's link with the rest of the country. The Eastern Railroad, the Salem-Reading Railroad, the Salem & Lowell Railroad, and the Essex Rail Line all ran passengers and freight from this station to points throughout New England and beyond. Passenger service to Boston via Salem from this depot ended in 1959. This site is now a municipal parking lot. (Peabody Historical Society collection.)

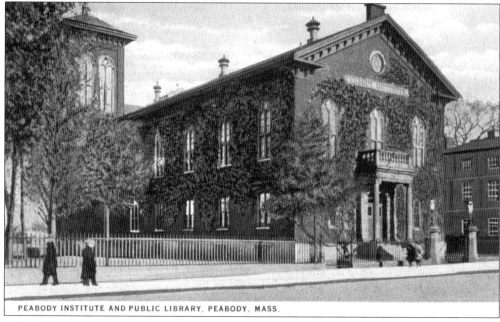

PEABODY INSTITUTE AND PUBLIC LIBRARY, PEABODY, MASS.

THE PEABODY INSTITUTE LIBRARY. The cornerstone for this Italianate Villa–style library, one of many endowed by George Peabody, was laid on August 20, 1853. It is the repository for many of the cherished gifts he received in recognition of his many charitable and social contributions throughout the world. The library continues to be a social, educational, and cultural landmark in the city of Peabody. (Peabody Historical Society collection.)

OBERLIN COLLEGE GLEE CLUB
Peabody Institute, Peabody, Mass.
8 P. M., Monday, April 3, 1911.

ADMISSION TICKET 35 CENTS

THE OBERLIN COLLEGE GLEE CLUB. The Peabody Institute served as a site for many of the city's cultural events, such as this visit from the Oberlin College Glee Club in 1911. (Andy Metropolis collection.)

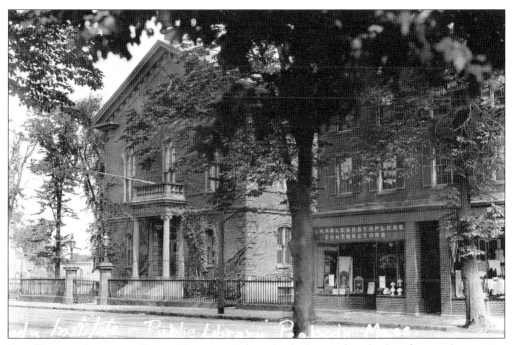

THE PEABODY INSTITUTE PUBLIC LIBRARY. Judging by the less verdant display of ivy on the exterior, this view of the library appears to predate the previous picture. The storefront lists the name of Charles H. Staples Company, Electrical Contractors. This storefront hides the front of the Federalist-style Dennison Wallis House, built in 1815. (Dave Cronin collection.)

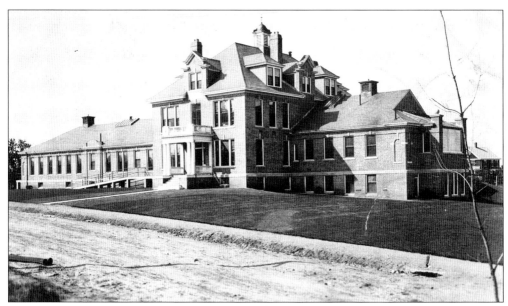

THE J.B. THOMAS HOSPITAL. The J.B. Thomas Hospital was built in 1907 with funds gained primarily from bequests. The largest donation of $90,000 was from the estate of Peabody businessman Josiah B. Thomas. (Michael Schulze collection.)

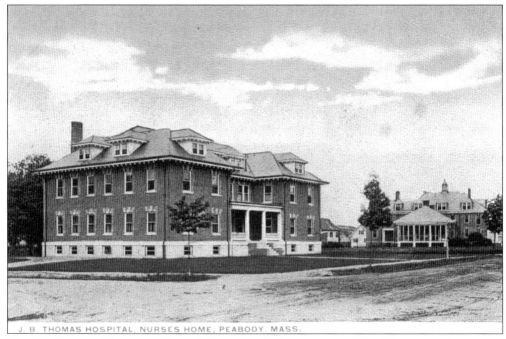

J. B. THOMAS HOSPITAL, NURSES HOME, PEABODY, MASS.

THE J.B. THOMAS HOSPITAL, NURSES' HOME. In 1915, the trustees of J.B. Thomas voted to expend $30,000 to construct a nurses' home for the growing hospital. (Michael Schulze collection.)

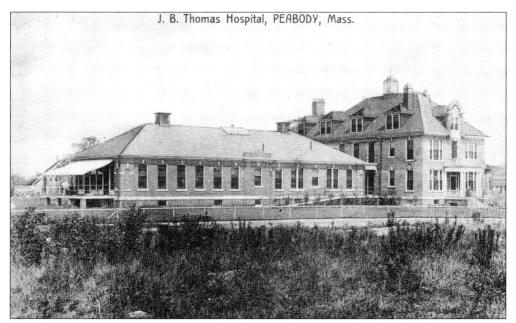

THE J.B. THOMAS HOSPITAL. Josiah B. Thomas came to Peabody in 1861 and soon became one of the city's most prosperous and influential businessmen. He dealt primarily in the wholesale meat business, but he was also involved in the manufacture of shoes and shoeboxes, leather and wool processing, and a large lumber concern. He was also the largest real-estate owner in the city. (Michael Schulze collection.)

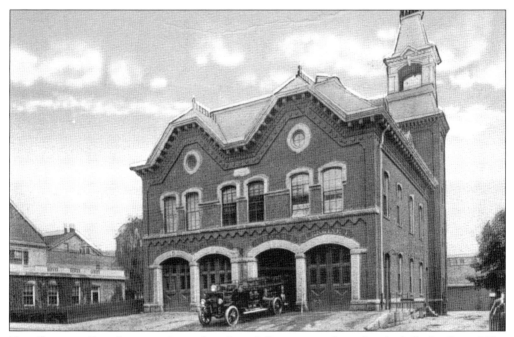

THE CENTRAL FIRE STATION. Located on Lowell Street across from the city hall, the Central Fire Station was built in 1873 and is reportedly the oldest central station still in use in the country. It was placed on the National Register of Historic Places by the Peabody Historical Commission and its chairman, John Wells. (Peabody Historical Society collection.)

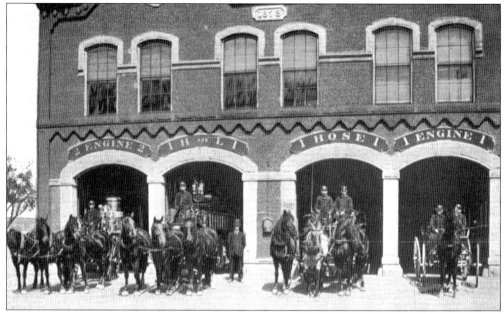

THE CENTRAL FIRE STATION, C. 1912. Proudly displayed in front of the Central Fire Station are a LaFrance steam engine, a hook-and-ladder truck, a combination truck, and an Amoskeag steam fire engine. (Michael Schulze collection.)

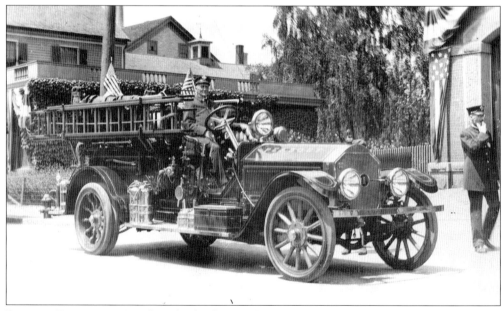

PEABODY ENGINE NO. 1. Judging by the flags and bunting in this image, Engine No. 1 has been in a parade. (Dave Cronin collection.)

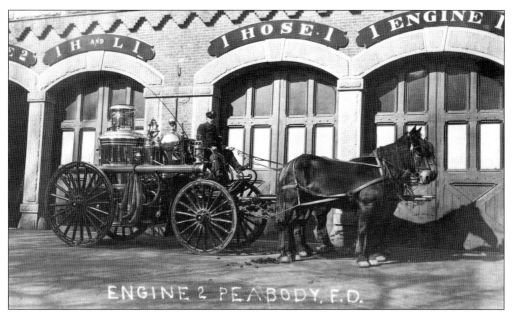

Peabody Engine No. 2. In this Kodak postcard, we have a fine view of Engine No. 2, which was housed at the Central Fire Station. (Michael Schulze collection.)

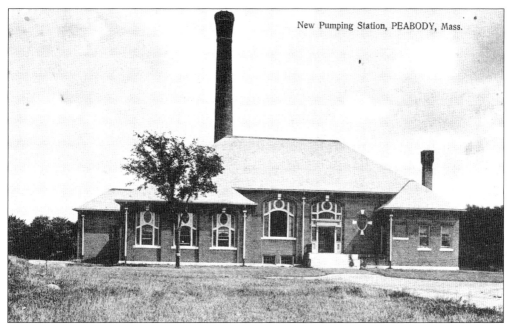

The New Pumping Station, Peabody. In the early 1900s, the town of Peabody undertook a major expansion of its water system. With the explosive growth of the leather industry, the aging waterworks on Washington Street was deemed inadequate to handle Peabody's future needs. The town built a new reservoir on Lookout Hill in South Peabody. Shortly thereafter, this new pumping station was built at the end of Coolidge Road. (Michael Schulze collection.)

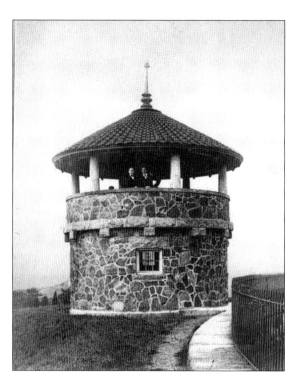

THE GATE HOUSE, PEABODY WATERWORKS. Once the land was cleared for the reservoir on Lookout Hill, a tower was built to take advantage of the spectacular view from the hill's elevation of 227 feet. These two friends are dressed in jackets and ties, as every male seemed to be in that era. (Dave Cronin collection.)

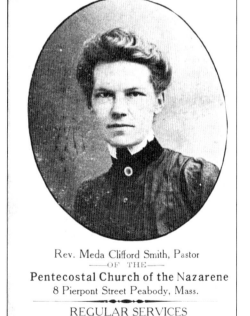

Rev. Meda Clifford Smith, Pastor
——OF THE——
Pentecostal Church of the Nazarene
8 Pierpont Street Peabody, Mass.

REGULAR SERVICES
Sunday, 9.30 a. m. Prayer, 10.30 a. m. and
7 p. m. Preaching, Sunday School 12 M.
Tuesday and Friday, at 7.30 p. m.

WELCOME TO ALL

THE PENTECOSTAL CHURCH OF THE NAZARENE, 1914. This organization was formed in 1899, and a church was built in 1906 on Pierpont Street. This postcard shows the pastor, Rev. Meda Clifford Smith. (Dave Cronin collection.)

THE SOUTH CONGREGATIONAL CHURCH, 1930s.
The South Congregational Church was formed in
1711. The church pictured here is the fourth on this
site. This beautiful Greek Revival structure was built
in 1844. In this view, we can also see the Soldiers and
Sailors Monument. (Michael Schulze collection.)

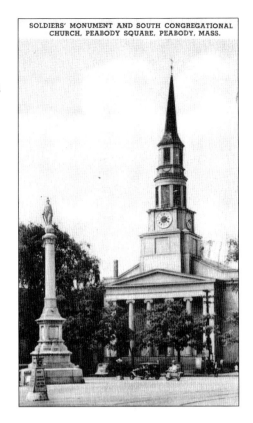

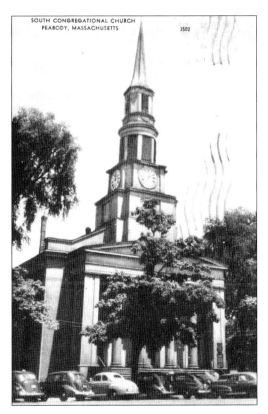

THE SOUTH CONGREGATIONAL CHURCH. The
church, shown here on a busy summer's day,
was razed in 1961 to make room for a gas
station. The current district courthouse
eventually replaced that station. The
congregation built a new church on Prospect
Street in 1963. (Michael Schulze collection.)

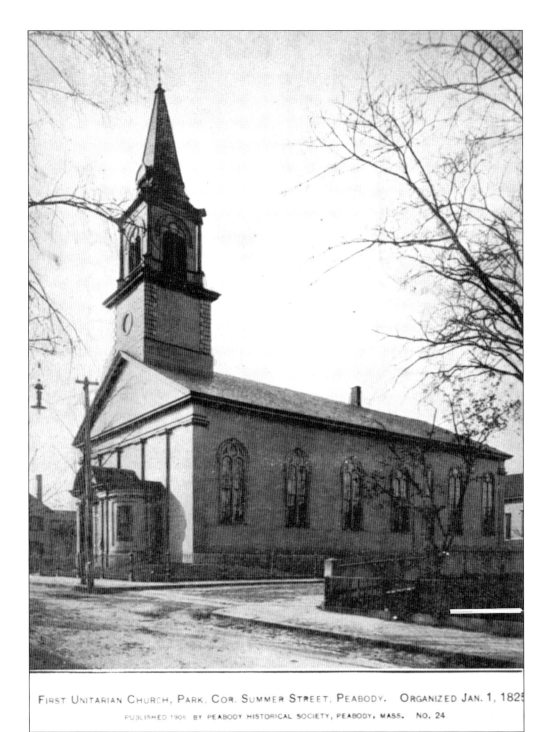

FIRST UNITARIAN CHURCH, PARK, COR. SUMMER STREET, PEABODY. ORGANIZED JAN. 1, 1825

PUBLISHED 1906 BY PEABODY HISTORICAL SOCIETY, PEABODY, MASS. NO. 24

THE FIRST UNITARIAN CHURCH. Located on historic Park Street, this former church is on the National Register of Historic Places. It was converted to condominiums in the 1980s. (Michael Schulze collection.)

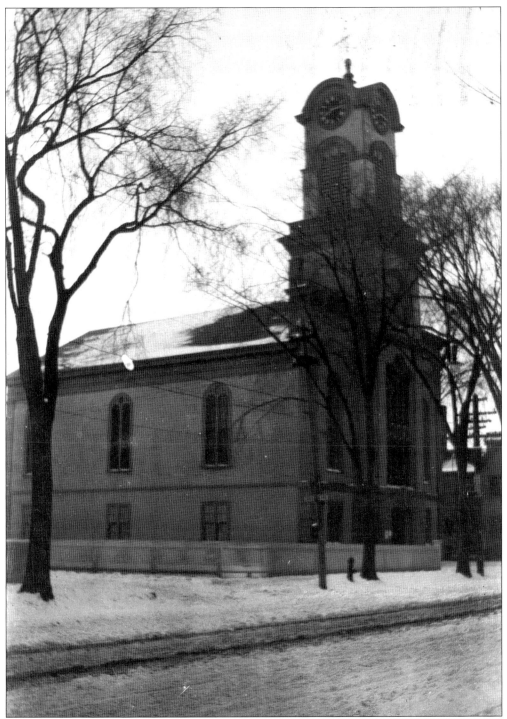

THE METHODIST CHURCH. The United Methodist Church originally served as the second South Congregational Church in Peabody Square. When that congregation needed a larger building, they sold this church to the Methodists for $2,500. It was then moved to the corner of Washington and Sewell Streets. (Dave Cronin collection.)

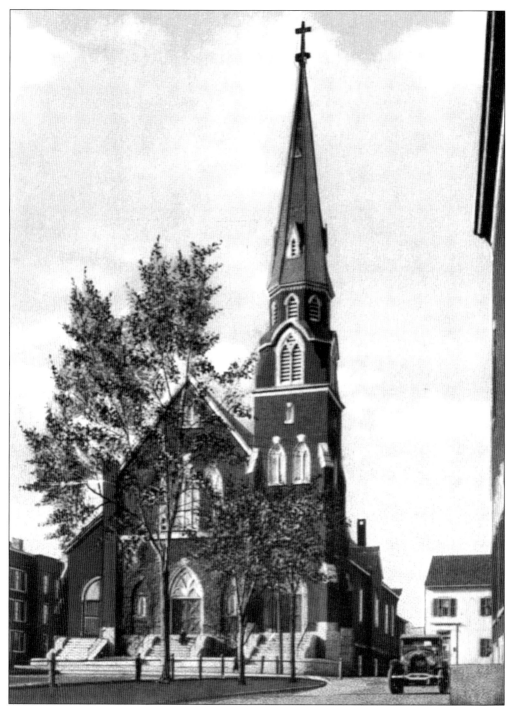

ST. JOHN'S CHURCH. The first Catholic church in Peabody, St. John's, was formed in 1871. The church was completed in 1879 and at that time was truly the grandest building in the city. At the dawn of the 20th century, it was estimated that the parish consisted of more than 5,000 people. Perhaps the person sitting at the top of the stairs is one of them. The brick building to the right is the back of the city hall. (Michael Schulze collection.)

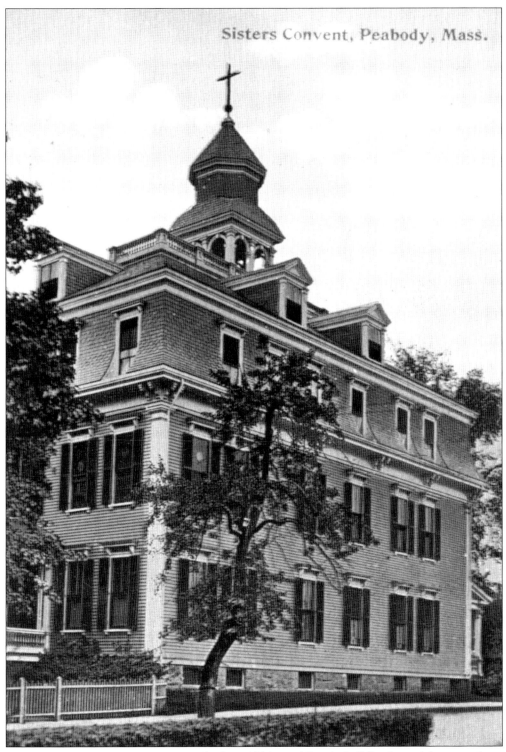

THE CONVENT, ST. JOHN'S CHURCH. This beautiful Second Empire building housed the many sisters who taught at the school. (Michael Schulze collection.)

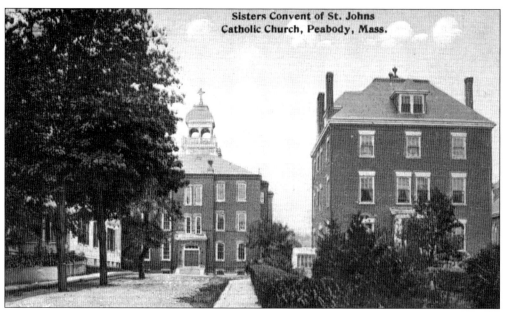

THE SCHOOL AND RECTORY OF ST. JOHN'S. This postcard is mislabeled as the convent. (Michael Schulze collection.)

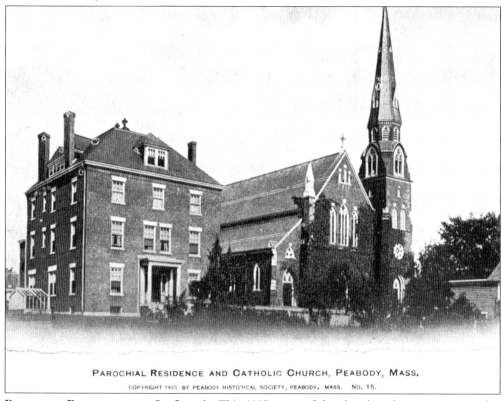

PAROCHIAL RESIDENCE AND ST. JOHN'S. This 1905 scene of the church and rectory is somewhat different from the view on page 50. The church is covered in vines, and the louvers on the belfry appear to be missing. (Peabody Historical Society collection.)

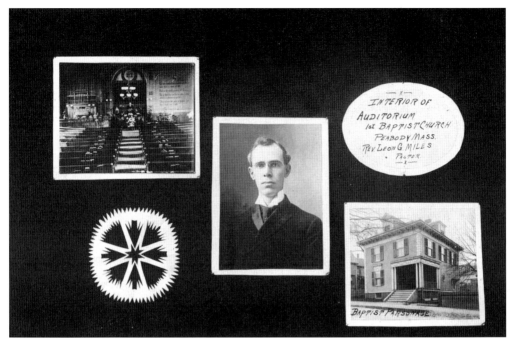

THE BAPTIST CHURCH. The First Baptist Church was founded in 1843. The church shown in this postcard was built in 1857 on Summer Street and survives to this day. It is currently called the Tabernacle Baptist Church. The three views presented here show the church's interior; its pastor, Reverend Miles; and the parsonage, located at 5 School Street. (Michael Schulze collection.)

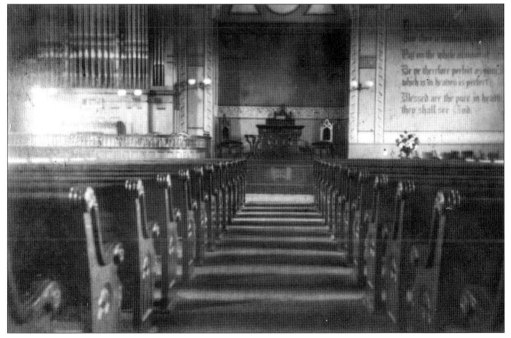

THE INTERIOR OF THE BAPTIST CHURCH. The interior of the church is dominated by the huge pipe organ on the left. (Michael Schulze collection.)

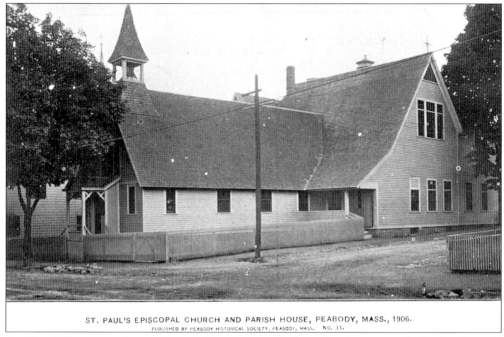

ST. PAUL'S EPISCOPAL CHURCH AND PARISH HOUSE, PEABODY, MASS., 1906.
PUBLISHED BY PEABODY HISTORICAL SOCIETY, PEABODY, MASS. NO. 33.

ST. PAUL'S EPISCOPAL CHURCH. St. Paul's was originally located at the corner of School and Lowell Streets. In 1913, the cornerstone for a new church was laid at 12 Washington Street, where it remains to this day. Currently, part of the old church serves as the hall for the Peabody Ancient Order of Hibernians. (Peabody Historical Society collection.)

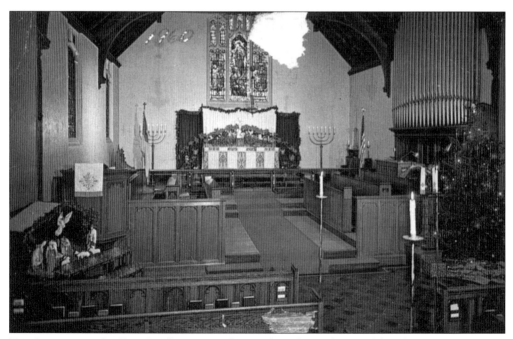

THE INTERIOR OF ST. PAUL'S. The interior of St. Paul's is shown decorated for Christmas 1960. (Dave Cronin collection.)

Four

MONUMENTS
AND CEMETERIES

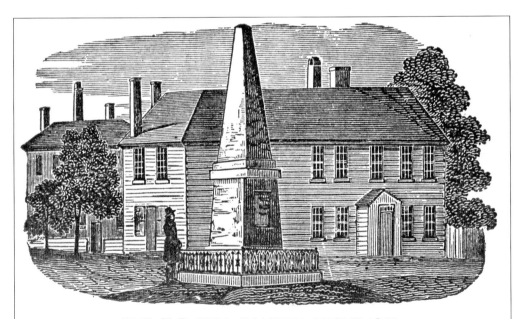

THE OLD BELL TAVERN ABOUT 1840
SOUTH-EAST COR. MAIN AND WASHINGTON STS. PEABODY

PUBLISHED BY PEABODY HISTORICAL SOCIETY, PEABODY, MASS. NO. 85.

THE OLD BELL TAVERN, C. 1840. Built in 1757, this tavern was a gathering place for departing Minutemen on their way to battle at Lexington and Concord and at Bunker Hill. It was located on the corner of Washington and Main Streets. This view shows the monument erected to memorialize those Minutemen who lost their lives on April 19, 1775. The tavern was taken down the same year. (Peabody Historical Society collection.)

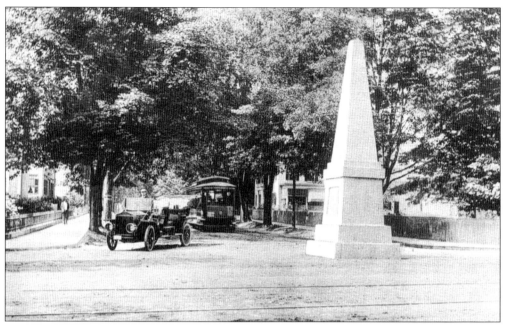

THE LEXINGTON MONUMENT. Erected in 1835, this was the first monument to the Battle of Lexington and Concord. It was deemed to be a traffic hazard and was moved to its present location on Washington Street in 1967. In this scene, we see both automobiles and streetcars making their way downtown. (Michael Schulze collection.)

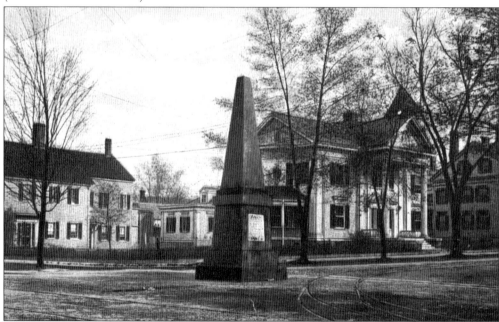

THE LEXINGTON MONUMENT. Originally located at the head of Washington and Main Streets, the monument was erected in 1835 to memorialize the seven Danvers citizens killed at the Battle of Lexington and Concord. Five of the Minutemen killed that day were from South Danvers (Peabody). They were Benjamin Deland, Samuel Cook, George Southwick, Henry Jacobs, and Ebenezer Goldwaithe. The Thomas O'Shea House (1896) is in the background. (Dave Cronin collection.)

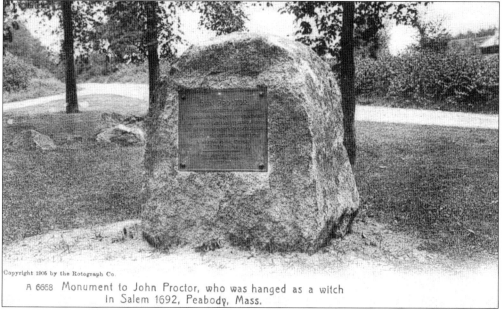

A 6668 Monument to John Proctor, who was hanged as a witch In Salem 1692, Peabody, Mass.

THE PROCTOR MEMORIAL. This memorial was erected by the descendants of John and Elizabeth Proctor, whose home still stands adjacent to this site. The story of their accusation and trial for witchcraft in 1692 was the basis of Arthur Miller's *The Crucible*. John was hanged in August of that year. Elizabeth was spared due to pregnancy. (Michael Schulze collection.)

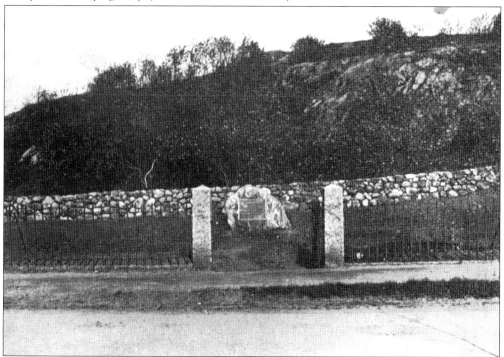

THE PRESCOTT MEMORIAL. This tablet and stone were erected by the descendants of Rev. Benjamin Prescott, the first pastor of the South Congregational Church. This tomb contains the remains of Prescott, his three wives, and many of their children. (Michael Schulze collection.)

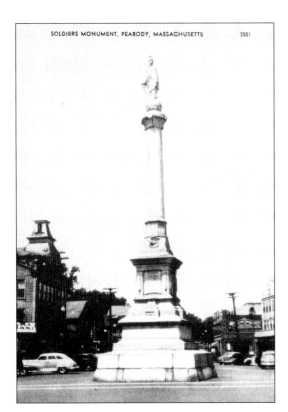

THE SOLDIERS AND SAILORS MONUMENT. This monument, erected in 1881, is dedicated to the soldiers and sailors of the Civil War. The statue of America atop the 50-foot-high spire is modeled on a similar one found upon the Capitol building in Washington, D.C. (Peabody Historical Society collection.)

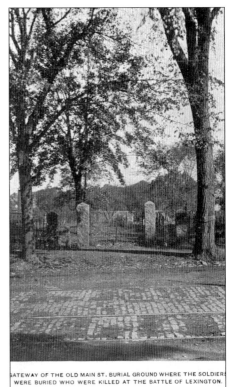

GATEWAY OF THE OLD MAIN ST. BURIAL GROUND WHERE THE SOLDIERS WERE BURIED WHO WERE KILLED AT THE BATTLE OF LEXINGTON.

PUBLISHED BY PEABODY HISTORICAL SOCIETY, PEABODY, MASS. NO. 80.

THE OLD SOUTH BURIAL GROUND, C. 1900. This photograph shows the cemetery's main gate, located on Main Street at the Salem line. The cemetery was the site of some of the earliest burials in Peabody. (Peabody Historical Society collection.)

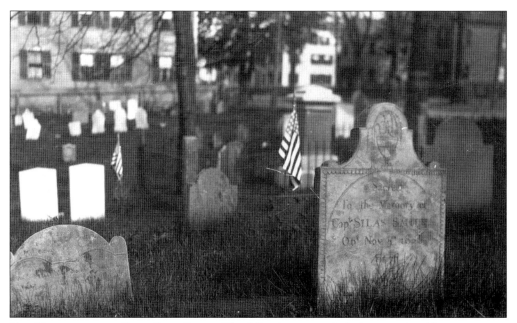

THE GRAVESTONE OF CAPT. SILAS SMITH. The following postcards depict some the oldest gravestones in Peabody. The city of Peabody has more than 45 cemeteries—one of which is the Old South Burial Ground, pictured here. In 2000, an ordinance was passed in an attempt to preserve these outdoor museums. Capt. Silas Smith was a ship's captain during the Revolutionary War era. (Peabody Historical Society collection.)

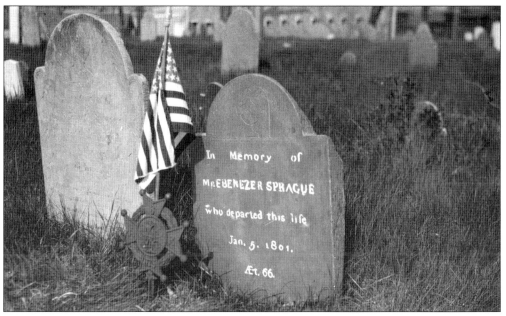

THE GRAVESTONE OF EBENEZER SPRAGUE. Slate was the primary material used for area gravestones during the 17th, 18th, and early 19th centuries. Although slate is subject to delamination and can be difficult to carve, it is generally durable. Thousands of slate stones, some more than 350 years old, are scattered throughout New England's burial grounds. (Peabody Historical Society collection.)

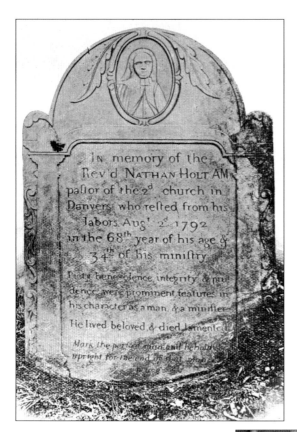

THE GRAVESTONE OF REV. NATHAN HOLT. Rev. Nathan Holt was the minister of the South Congregational Church in Peabody Square. On Sunday, February 26, 1775, at word that the British were marching on Danvers, Holt cut short his sermon and joined an armed group of men racing to intercept the English troops. They met at the North Bridge in Salem, where after some delicate negotiations, the British retreated back to Boston. (Peabody Historical Society collection.)

THE BURIAL SITE OF BENJAMIN JACOBS. A lieutenant during the Revolutionary War, Benjamin Jacobs was a member of a prominent family in Peabody. There are two Jacobs family burial grounds in town—one on Margin Street and another on Lowell Street. (Peabody Historical Society collection.)

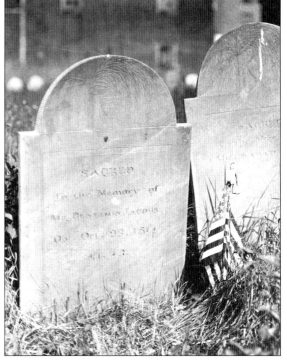

SACRED TO THE MEMORY OF MAJ. CALEB LOW. On April 19, 1775, Capt. Caleb Low led his company of Danvers (now Peabody) men into battle at Lexington and Concord. On their approach, they met British troops at Arlington Heights and, along with the other companies from Danvers, suffered through fierce fighting with many casualties. (Peabody Historical Society collection.)

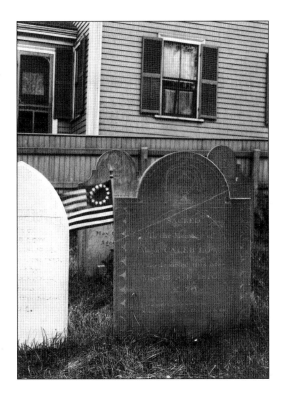

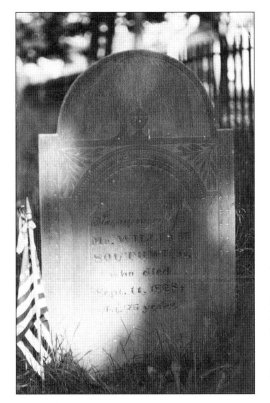

THE GRAVESTONE OF WILLIAM SOUTHWICK. In 1996, the Historic Graveyard Coalition was formed by Ann Birkner, Betty Cassidy, William R. Power, and Cam Soutter to research, preserve, and protect the historic graveyards of Peabody. The group sought to establish a comprehensive database of biographical information on those interred in Peabody's historic burial grounds. (Peabody Historical Society collection.)

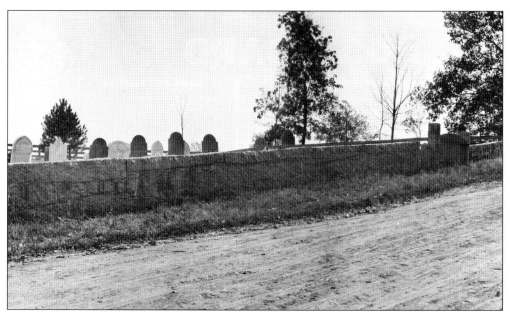

THE KING-HUSSEY CEMETERY. This cemetery, located on Summit Street, is one of more than 40 historic burial grounds in Peabody. The cemetery contains the remains of Amos King; his wife, Mary Marsh King; and their descendants. It dates from at least 1820. Another King family cemetery is nearby on Lowell Street. (Peabody Historical Society collection.)

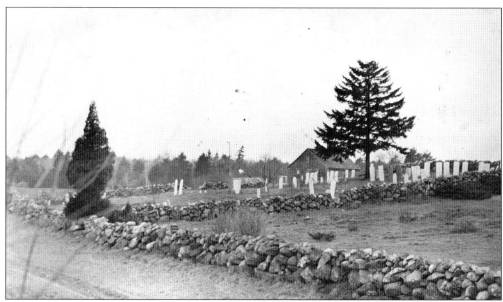

THE BROWN-SOUTHWICK CEMETERY. Located at the end of Nichol's Lane off Winona Street in West Peabody, this is the final resting place of many from the Brown, Southwick, Foster, and Herrick families. An old house is visible in the background. The Viles family owned it when this postcard was printed *c.* 1908. (Peabody Historical Society collection.)

Five
HOUSES AND HOMES

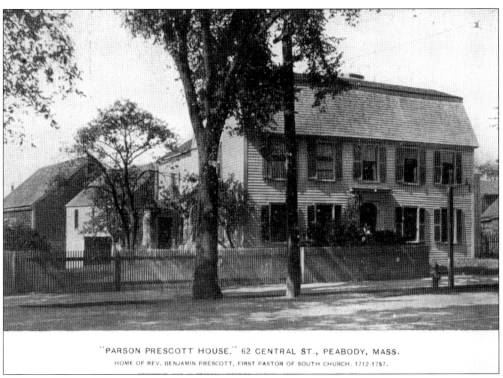

"PARSON PRESCOTT HOUSE," 62 CENTRAL ST., PEABODY, MASS.
HOME OF REV. BENJAMIN PRESCOTT, FIRST PASTOR OF SOUTH CHURCH. 1712-1757.

THE PARSON PRESCOTT HOUSE. Upon graduating Harvard College in 1709, Benjamin Prescott became the first pastor of the South Congregational Church. This house, which was located at 72 Central Street, was built *c.* 1748 as a wedding present to the Prescotts from the bride's family. The house was damaged by fire *c.* 1900 and was demolished. (Michael Schulze collection.)

"GREAT ENTRY" IN PARSON PRESCOTT HOUSE.
72 CENTRAL ST., PEABODY, MASS.

PUBLISHED BY PEABODY HISTORICAL SOCIETY, PEABODY, MASS., 1913. NO. 7

THE GREAT ENTRY HALL OF THE PRESCOTT HOUSE. Rev. Benjamin Prescott, his three wives, and many of their children are buried in the Prescott Memorial Burial Ground on Tremont Street. (Peabody Historical Society collection.)

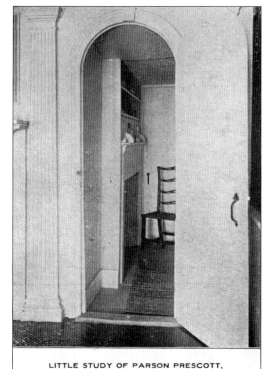

LITTLE STUDY OF PARSON PRESCOTT,
72 CENTRAL ST., PEABODY, MASS.

PUBLISHED BY PEABODY HISTORICAL SOCIETY, PEABODY, MASS., 1913. NO. 70.

THE STUDY IN THE PRESCOTT HOUSE. Rev. Benjamin Prescott's first wife was the daughter of Colonial governor Sir William Pepperell. (Peabody Historical Society collection.)

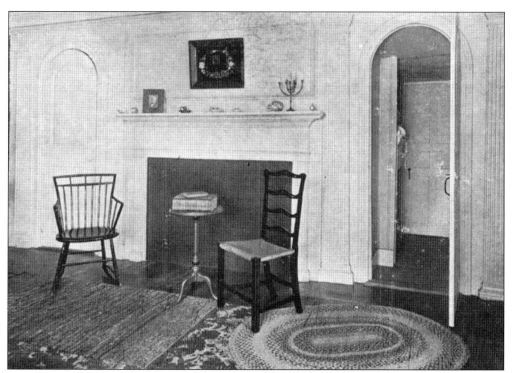

ANOTHER ROOM IN THE PRESCOTT HOUSE. Rev. Benjamin Prescott's granddaughter Rebecca was married in this house to Roger Sherman, a signer of both the Declaration of Independence and the Constitution. (Michael Schulze collection.)

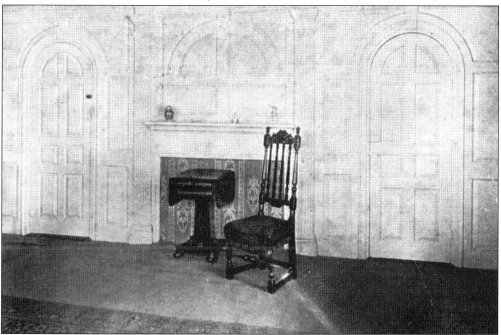

THE PRESCOTT HOUSE PARLOR. The Prescott House, comprising 15 rooms, was one of the grandest homes in Peabody. (Peabody Historical Society collection.)

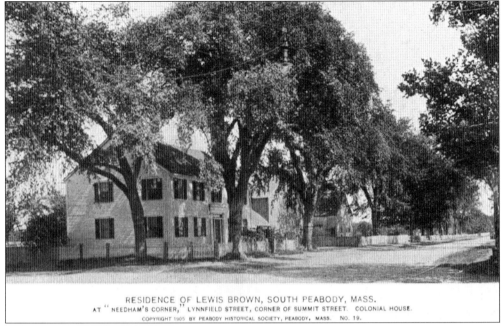

RESIDENCE OF LEWIS BROWN, SOUTH PEABODY, MASS.
AT "NEEDHAM'S CORNER," LYNNFIELD STREET, CORNER OF SUMMIT STREET. COLONIAL HOUSE.
COPYRIGHT 1905 BY PEABODY HISTORICAL SOCIETY, PEABODY, MASS. NO. 19.

THE LEWIS BROWN HOME. Originally home to the Needham family, this house (on the corner of Summit and Lynnfield Streets) soon became the home of the Browns, who were stonecutters and quarrymen. One of the residents of this house was Samuel Brown, who was killed at Antietam and for whom the Brown School is named. The note on the card states that the barn on this property was used as a Quaker meetinghouse as early as 1716. The site is now occupied by a gas station. (Michael Schulze collection.)

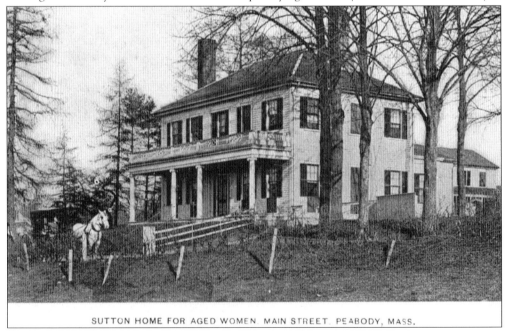

SUTTON HOME FOR AGED WOMEN. MAIN STREET. PEABODY, MASS.

THE SUTTON HOME FOR AGED WOMEN. This building was originally the home of William Sutton. It was built in 1821 and was set back from Main Street. The property originally extended back to the other side of Aborn Street. The house was destroyed by fire in 1965. (Michael Schulze collection.)

THE DENNISON WALLIS HOUSE. At the age of 19, Dennison Wallis was one of many from the area who marched to fight the British at Lexington on April 19, 1775. A member of Capt. Gideon Foster's Minutemen, Wallis was wounded 11 times in a fierce fight with British troops at Menotomy (Arlington Heights). He survived and lived to a ripe old age. (Michael Schulze collection.)

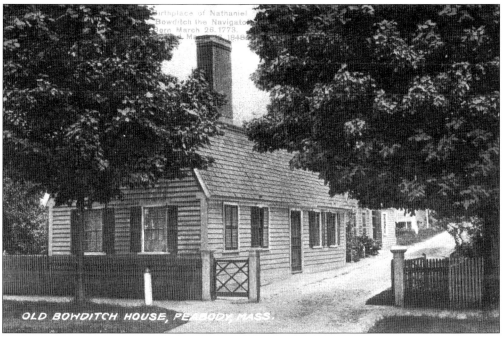

OLD BOWDITCH HOUSE, PEABODY, MASS.

THE NATHANIEL BOWDITCH HOUSE. Nathaniel Bowditch (or "the Navigator," as he became known) was born in this home, built *c.* 1761 and still standing in Wilson Square. He moved with his family to Salem at an early age and went on to become world renowned as the author of *The Practical Navigator.* (Michael Schulze collection.)

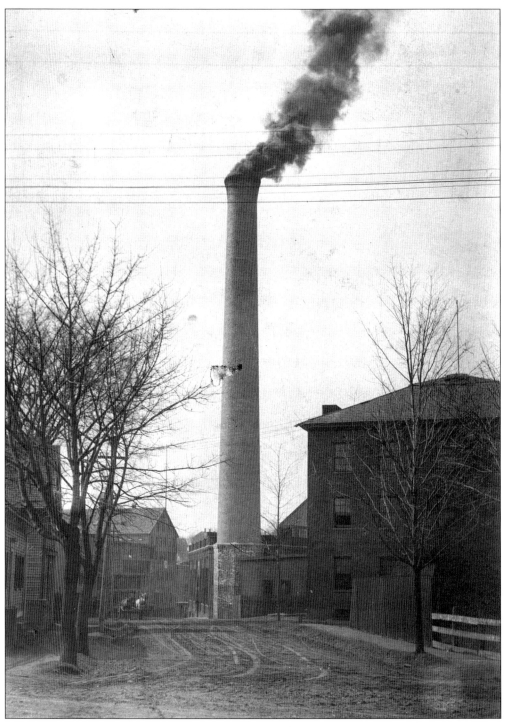

THE RICHARD CROWNINSHIELD HOUSE. Richard Crowninshield, a member of that celebrated Salem family, built his mansion in 1815 where it stands today on Crowninshield Street. It is at the center of what was his mill complex. An underground passage connected the house with the mill. (Peabody Historical Society collection.)

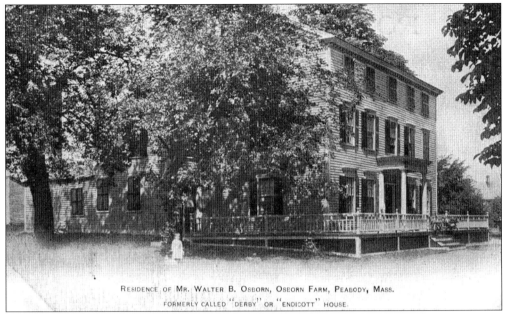

RESIDENCE OF MR. WALTER B. OSBORN, OSEORN FARM, PEABODY, MASS.
FORMERLY CALLED "DERBY" OR "ENDICOTT" HOUSE.

THE OSBORN FARM. Located near Buttonwood Lane and originally part of the Eppes property, the farm was sold to Salem merchant Elias Haskett Derby in 1776. Derby invested large sums of money over the next few years to enlarge the house and enhance the beautiful grounds. The famous *c.* 1793 McIntire summer house (now at the Endicott Estate in Danvers) was originally on this site. A McIntire-designed barn was moved to Watertown in 1925. (Michael Schulze collection.)

THE JOHN PROCTOR HOUSE, C. 1646. Famed throughout the world as one of the settings for *The Crucible,* this was the home of John and Elizabeth Proctor, who were both tried and convicted of practicing witchcraft. John was hanged on August 19, 1692. Elizabeth's hanging was postponed because of her pregnancy. Fortunately, the hysteria had passed by the time of her baby's birth, and she was spared. (Michael Schulze collection.)

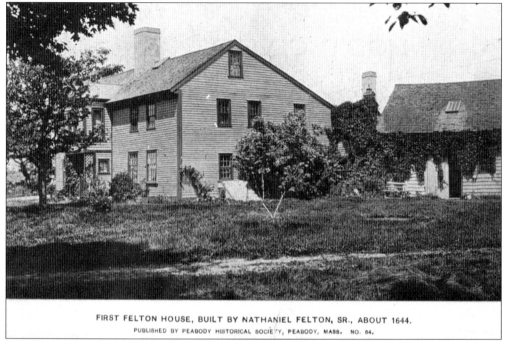

FIRST FELTON HOUSE, BUILT BY NATHANIEL FELTON, SR., ABOUT 1644.
PUBLISHED BY PEABODY HISTORICAL SOCIETY, PEABODY, MASS. NO. 64.

THE NATHANIEL FELTON SR. HOUSE. This site has been occupied by a Felton family home since 1644. The Feltons came up the North River from Salem to Peabody Square and settled on Hog Hill *c.* 1640. For the next 250 years, the family played a major role in the development of the city. The home, possibly the oldest existing house in Peabody, is now a part of the Peabody Historical Society and Museum. (Michael Schulze collection.)

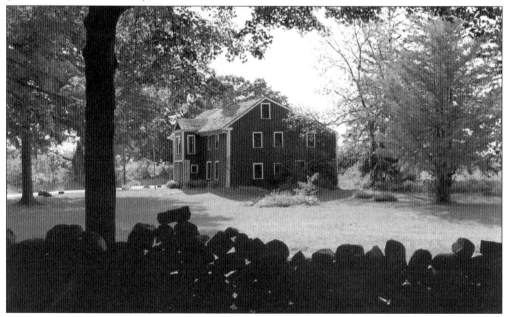

THE NATHANIEL FELTON SR. HOUSE, A MORE RECENT VIEW. The Nathaniel Felton Sr. House is located at the Peabody Historical Society's Felton-Smith Historic Site at the entrance to Brooksby Farm. (Peabody Historical Society collection.)

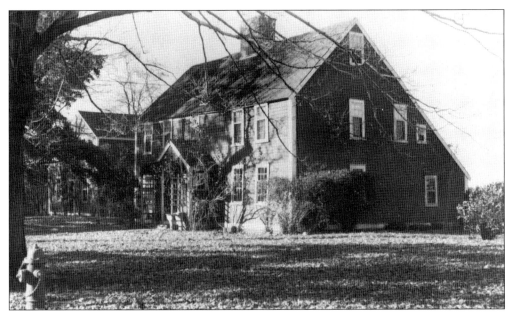

THE NATHANIEL FELTON JR. HOUSE. This Felton house was built *c.* 1683. It was sold in to Malachi Felton, who moved it to its current location on Felton Street. It became a part of the Smith Farm and, in 1976, was donated to the Peabody Historical Society. (Andy Metropolis collection.)

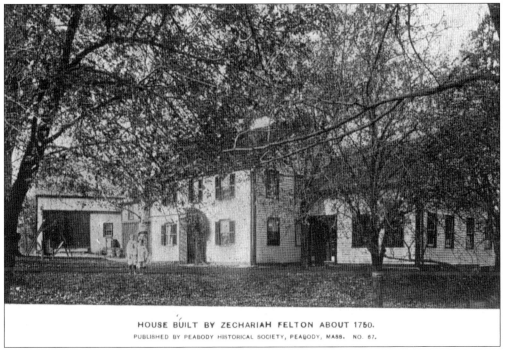

HOUSE BUILT BY ZECHARIAH FELTON ABOUT 1750.
PUBLISHED BY PEABODY HISTORICAL SOCIETY, PEABODY, MASS. NO. 67.

THE ZECHARIAH FELTON HOUSE. This farmhouse, built *c.* 1750, was located on Felton Street between the present-day corner of Mount Pleasant and Felton Streets and Felton Terrace. It was destroyed by fire in the 1920s. (Michael Schulze collection.)

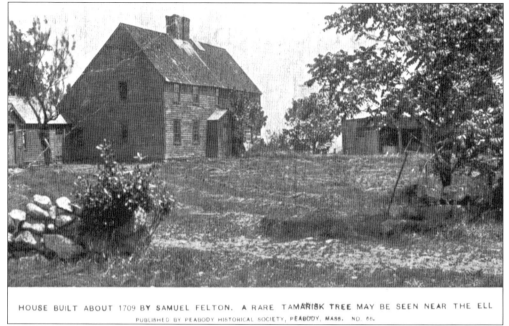

THE SAMUEL FELTON HOUSE. Originally built in 1674 and enlarged in 1709, this house stood roughly near the present-day corner of Hog Hill Road and Felton Street. In the 1920s, the owners of the Smith Farm (Brooksby) used the house for storage. After a fire in 1925, the undamaged frame was moved first to Maine and then to Andover. (Michael Schulze collection.)

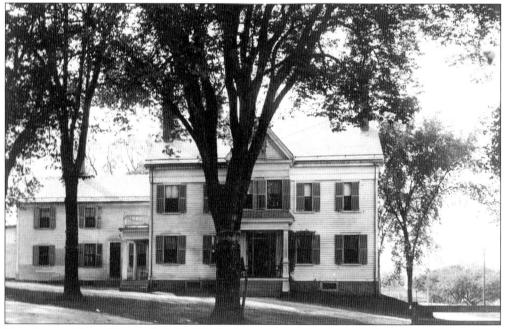

THE SAMUEL KING HOUSE. Built in 1846 by Samuel King, this beautiful home is on the corner of Forrest Street and Lowell. One of the many homes built in the area known as the Kingdom by the King family, it served as a stop on the Underground Railroad in the years before the Civil War. (Peabody Historical Society collection.)

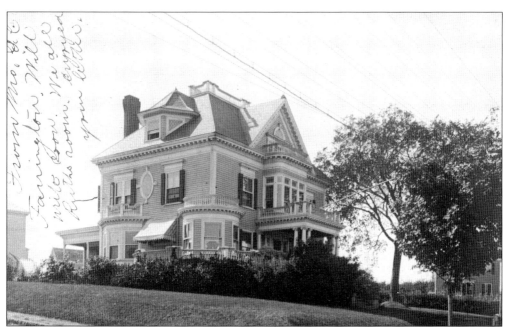

THE FARRINGTON HOUSE. This lovely Queen Anne–style home, built *c.* 1890, still stands at 158 Lowell Street. (Michael Schulze collection.)

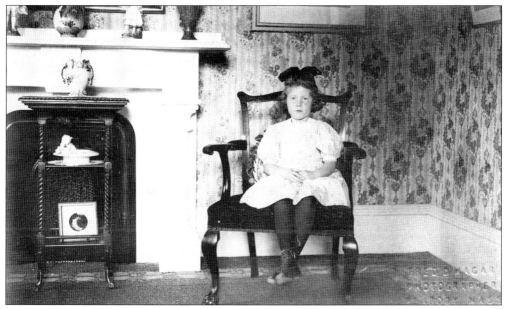

GEORGE WASHINGTON'S CHAIR. The chair in which young Katherine Underwood is seated was used by George Washington when he visited Salem in 1789. In 1908, when this postcard was issued, the chair was in the possession of Lucy Symonds of 171 Lowell Street. (Peabody Historical Society collection.)

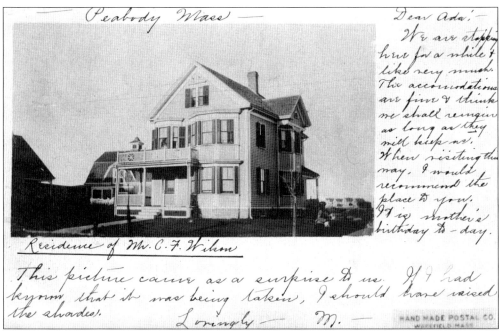

Peabody Mass —

Dear Ada;—
We are stop[ing]
here for a while &
like very much.
The accommodations
are fine & think
we shall remain
as long as they
will keep us.
When visiting th[is]
way, I would
recommend the
place to you.
It is mother's
birthday to-day.

Residence of Mr. C. F. Wilson

This picture came as a surprise to us. If I had
known that it was being taken, I should have raised
the shades.
Lovingly — M. —

HAND MADE POSTAL CO.
WAKEFIELD, MASS.

THE C.F. WILSON HOME. This photo postcard, made by the Handmade Postal Card Company of Wakefield, was mailed in 1908. The house still exists on Andover Street near the entrance to Buttonwood Lane. (Michael Schulze collection.)

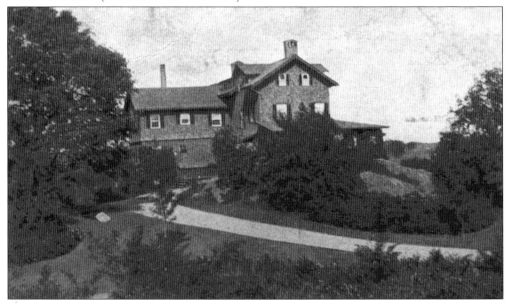

THE GEN. FRANCIS APPLETON HOUSE. The Appleton farm, once on the shores of Lake Suntaug in West Peabody, was renowned for its beautiful buildings and grounds. The general, who received his commission in the National Guard, was a renowned agriculturist and breeder. He served as the president of many agricultural organizations throughout the state. Both a state senator and representative, he was chairman of the state Republican party and president of the Peabody Historical Society. This is a picture of his second home, located on Prospect Street. The Carmelite Order now owns it. (Michael Schulze collection.)

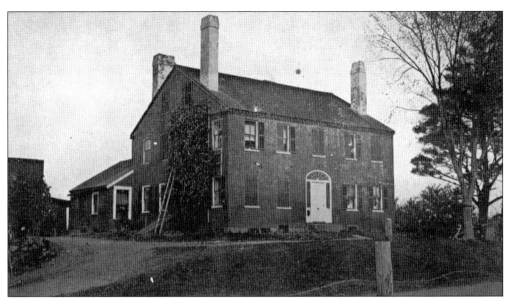

THE THORNDIKE EARLE HOUSE. This house, which still stands today on Prospect Street, was built by Thorndike Proctor in 1817. It replaced James Houlton's home, which burned in 1815. Houlton's house was the site of the first school in Peabody. (Peabody Historical Society collection.)

KATHERINE DALAND'S SIGNATURE, C. 1713. Katherine Daland was the first formal schoolteacher in Peabody. She first taught at the James Houlton house on Prospect Street in the early 1700s. She then moved to the town's first official schoolhouse, located at 62 Central Street. (Peabody Historical Society collection.)

A Rose Bush, c. 1914. This rose bush was growing on the property of James Houlton when Katherine Daland was a teacher there. (Peabody Historical Society collection.)

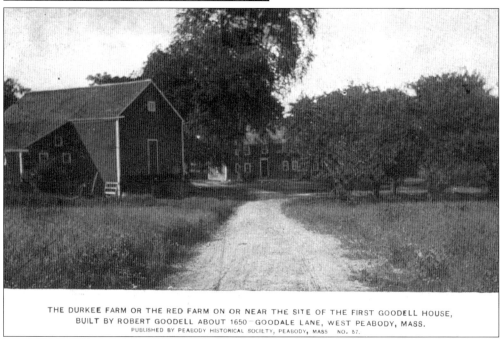

THE DURKEE FARM OR THE RED FARM ON OR NEAR THE SITE OF THE FIRST GOODELL HOUSE, BUILT BY ROBERT GOODELL ABOUT 1650 GOODALE LANE, WEST PEABODY, MASS.
PUBLISHED BY PEABODY HISTORICAL SOCIETY, PEABODY, MASS NO. 57.

The Red Farm. This farm was situated on Goodale Street, near the present Donna Road area. Robert Goodell (Goodale) built the farmhouse c. 1650, and it was in the Durkee family for many years. The house burned down in the late 1970s. (Peabody Historical Society collection.)

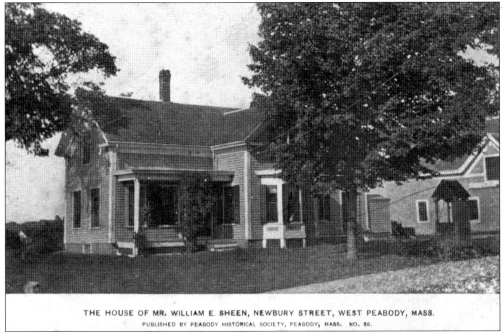

THE HOUSE OF MR. WILLIAM E. SHEEN, NEWBURY STREET, WEST PEABODY, MASS.
PUBLISHED BY PEABODY HISTORICAL SOCIETY, PEABODY, MASS. NO. 68.

THE WILLIAM SHEEN HOME. The William Sheen home was situated on the northbound side of Newbury Street (Route 1) between Forest and Lowell Streets. William Sheen and most of his family are buried at Oak Grove Cemetery in West Peabody. (Peabody Historical Society collection.)

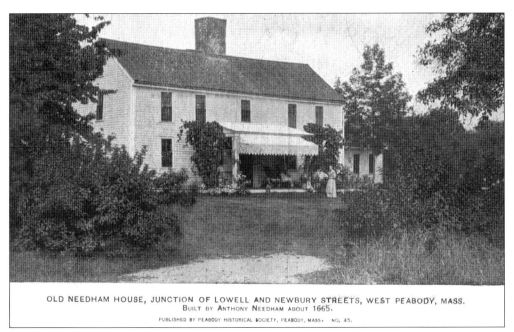

OLD NEEDHAM HOUSE, JUNCTION OF LOWELL AND NEWBURY STREETS, WEST PEABODY, MASS.
BUILT BY ANTHONY NEEDHAM ABOUT 1665.
PUBLISHED BY PEABODY HISTORICAL SOCIETY, PEABODY, MASS. NO. 45.

THE OLD NEEDHAM HOUSE. Built *c.* 1665, this house is one of many built by the Needham family in the area known as Locustdale, which was located at the junction of Lowell and Newbury Streets. This house was demolished in 1966 to make way for a gas station. (Peabody Historical Society collection.)

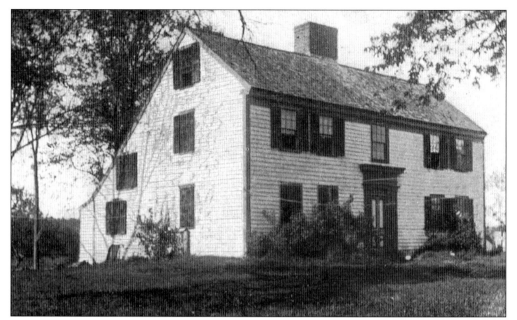

THE LT. GEORGE GARDNER HOUSE. The Lt. George Gardner House was built in 1670 and was at the center of a 400-acre farm. Although modified, it still stands on Bow Street near Lowell Street. (Peabody Historical Society collection.)

THE JOHN HERRICK HOUSE. The Pope family originally owned this property. It centered on the current Herrick Estates, near the Lowell Street area in West Peabody. The land was sold to James Foster, and he built this house *c.* 1775. The house then passed into the family of John Herrick. The home burned down in 1948. (Peabody Historical Society collection.)

Six

WHEN LEATHER WAS KING

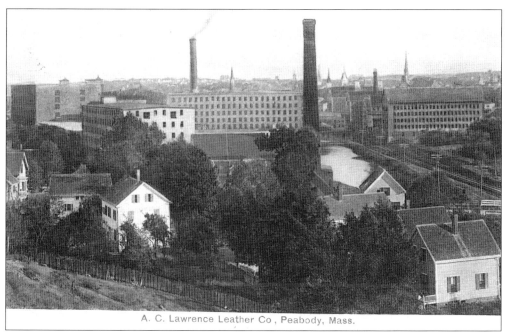

A. C. Lawrence Leather Co , Peabody, Mass.

THE A.C. LAWRENCE LEATHER COMPANY. Founded in 1894 with three sprawling plants, the A.C. Lawrence Leather Company soon became one of the largest leather producers in the world. Manufacturers of sheep, calfskin, and patent leathers, the company was an innovator in the tanning process, helping to make Peabody the Leather City. This card, published by D.H. Bresnahan, was mailed in 1909. (Michael Schulze collection.)

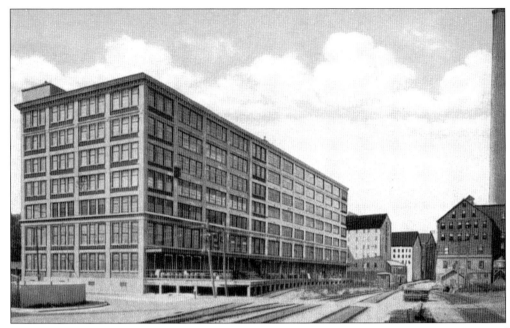

THE A.C. LAWRENCE LEATHER COMPANY, MAIN PLANT. The main plant was built around the site of the old Crowninshield Mill and Crowninshield Pond. Arthur Lawrence, in partnership with L.B. Southwick, began the complex in 1894. The growth of this company was explosive. Within 15 years, it employed more than 2,000 workers and was well on its way to becoming the largest leather producer in the world. (Michael Schulze collection.)

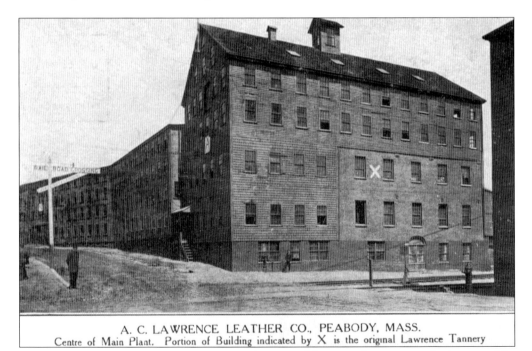

A. C. LAWRENCE LEATHER CO., PEABODY, MASS.
Centre of Main Plant. Portion of Building indicated by X is the original Lawrence Tannery

THE A.C. LAWRENCE LEATHER COMPANY. In this view of the main plant, an X marks the spot of the original building of the A.C. Lawrence plant built in the 1890s. (Dave Cronin collection.)

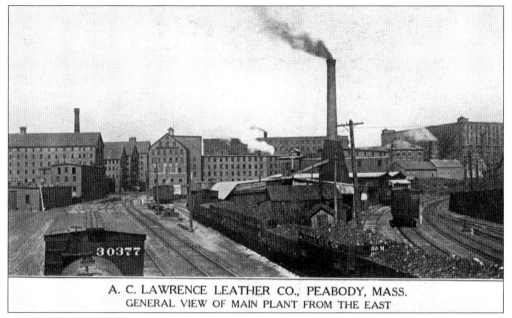

A. C. LAWRENCE LEATHER CO., PEABODY, MASS.
GENERAL VIEW OF MAIN PLANT FROM THE EAST

A.C. LAWRENCE, THE VIEW FROM THE EAST. In this view, a train of the Boston & Maine Railroad delivers coal to be used in the A.C. Lawrence power plant. Peabody's proximity to Lynn (the world's largest producer of women's shoes) and Brockton (the men's shoe capital of the world) helped to drive the rapid expansion of the leather industry and make Peabody the leather capital of the world. (Michael Schulze collection.)

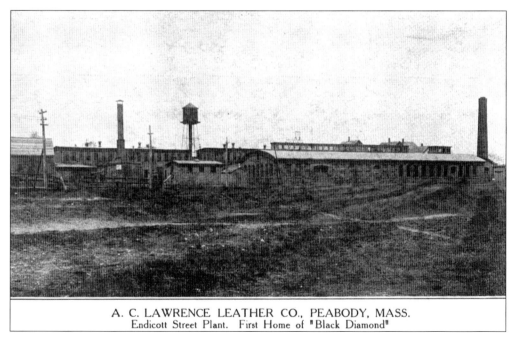

A. C. LAWRENCE LEATHER CO., PEABODY, MASS.
Endicott Street Plant. First Home of "Black Diamond"

THE ENDICOTT STREET PLANT. Of the more than 60 leather manufacturers in the city of Peabody, A.C. Lawrence was the largest. It was, in fact, the largest leather processor in the world. The Endicott Street plant was a japanning facility, where leather would be finished with lacquers. (Michael Schulze collection.)

81

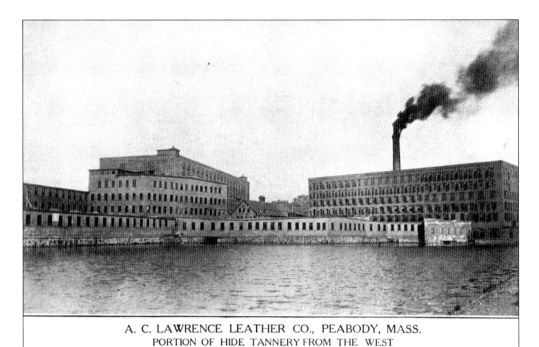

A. C. LAWRENCE LEATHER CO., PEABODY, MASS.
PORTION OF HIDE TANNERY FROM THE WEST

THE A.C. LAWRENCE HIDE TANNERY. This view of the building was taken from across Crowninshield Pond. At its peak, A.C. Lawrence employed in excess of 3,000 people in its Peabody operations. (Michael Schulze collection.)

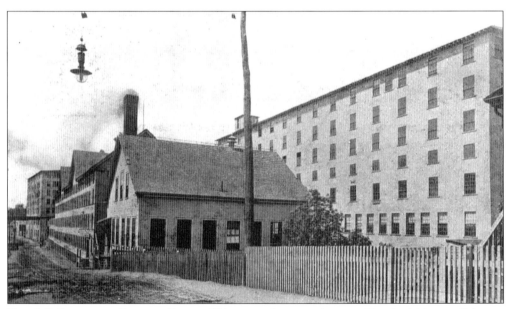

THE A.C. LAWRENCE CALFSKIN PLANT. This postcard was sent home to Lincoln, Maine, on February 10, 1920. Many postcards were sent from Peabody back home to New Hampshire and Maine by the hundreds of people who came south looking for work in leather manufacturing at the turn of the century. (Michael Schulze collection.)

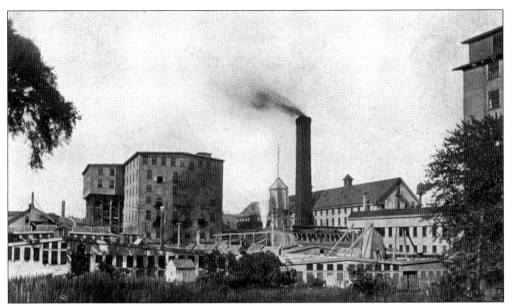

THE A.C. LAWRENCE CALFSKIN PLANT. Pictured is another view of the calfskin plant. (Michael Schulze collection.)

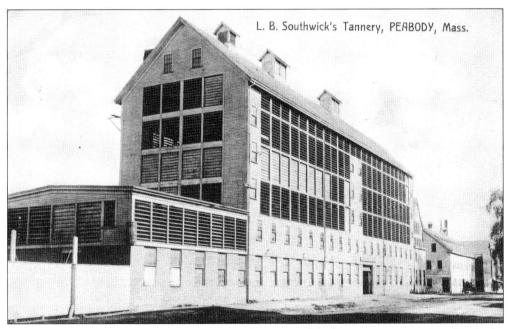

L. B. Southwick's Tannery, PEABODY, Mass.

L.B. SOUTHWICK'S TANNERY. J.B. Thomas was the owner of the largest meat-processing plant in the area. In order to make use of the large amount of animal skins this generated, J.B. Thomas formed a partnership with L.B. Southwick, whose family had been active in the leather industry for many years. On this card, a man identified only as "father" writes to "mother" in New Hampshire, "It seems like snow. May go to the pictures tonight and see *Girl of the Golden West.*" (Michael Schulze collection.)

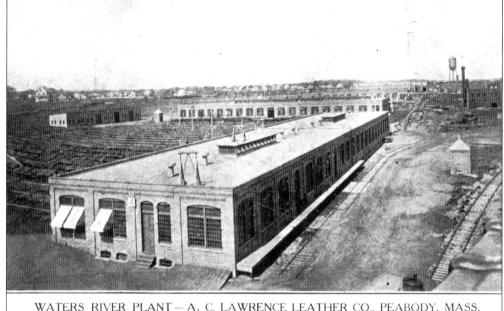

WATERS RIVER PLANT — A. C. LAWRENCE LEATHER CO., PEABODY, MASS.
NEW HOME OF "BLACK DIAMOND"

THE A.C. LAWRENCE WATERS RIVER PLANT. This huge plant was used primarily for the manufacture of patent leather. (Michael Schulze collection.)

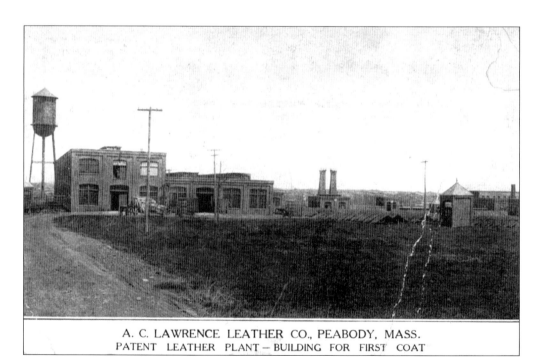

A. C. LAWRENCE LEATHER CO., PEABODY, MASS.
PATENT LEATHER PLANT — BUILDING FOR FIRST COAT

THE A.C. LAWRENCE PATENT LEATHER PLANT. Another part of the patent leather plant is shown here. (Michael Schulze collection.)

84

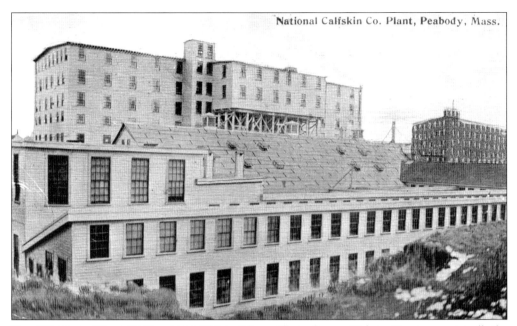

THE NATIONAL CALFSKIN COMPANY. This building, still standing on Webster Street, was originally the home of the Proctor Tanning Company, one of Peabody's earliest leather producers. At the beginning of the 20th century, there were more than 60 firms engaged in the leather industry. In 1906, this company became part of A.C. Lawrence. (Michael Schulze collection.)

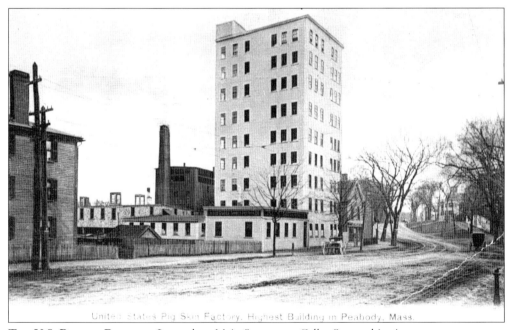

THE U.S. PIGSKIN FACTORY. Located on Main Street near Caller Street, this nine-story structure was the home of the U.S. Pigskin Factory. The company imported pigskins from out west to be used in the manufacture of (among other things) footballs—hence, the term *pigskin* for a football. After some time, the factory began to lean precariously and had to be demolished. (Michael Schulze collection.)

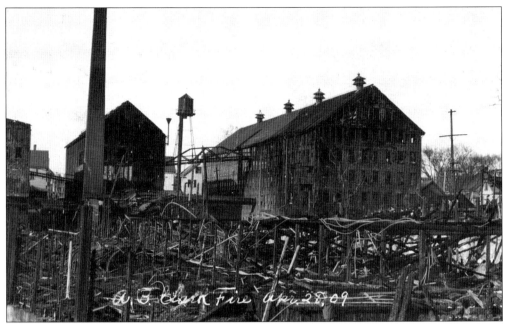

A Fire at the A.C. Clark Factory. On this card, Sadie writes to Jessie Brodie of Melrose on May 3, 1909, "Here is a card showing the awful fire we had and nothing but the rain and good work of firemen saved our house. I had our clothes packed, ready to go and my heart was breaking to think how everything would have to go up in smoke and fire." A.C. Clark was known as the "sheepskin king." His plant continued on for many years after this fire. (Dave Cronin collection.)

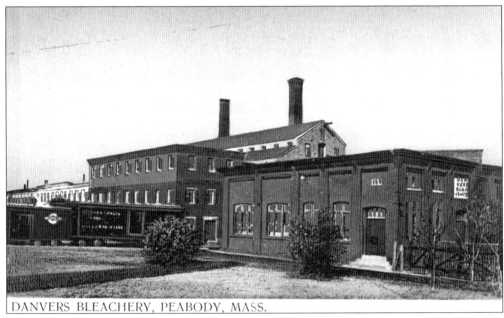

DANVERS BLEACHERY, PEABODY, MASS.

The Danvers Bleachery, Peabody. While leather dominated the manufacturing industry in Peabody, other companies grew up there because of its plentiful and pure supply of water. The Danvers Bleachery was one such company. The bleachery colored hundreds of tons of textiles and, at one time, employed more than 1,000 people. (Dave Cronin collection.)

Seven

SCHOOLS AND CLUBS

PEABODY'S OLDEST SCHOOL BUILDING, DISTRICT NO. 1. Built *c.* 1730 on Main Street next to the Old South Cemetery, the schoolhouse was moved to Grove Street (Howley Street) when the second schoolhouse was built. (Peabody Historical Society collection.)

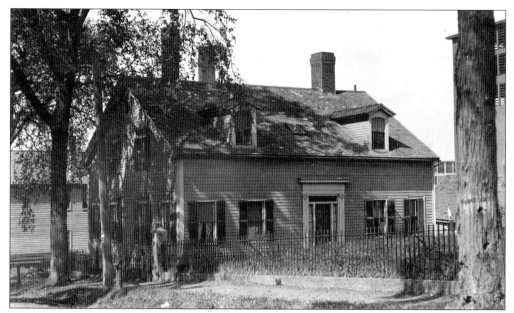

THE SECOND SCHOOLHOUSE IN DISTRICT NO. 1. Built to replace the schoolhouse in the previous picture, this building eventually became a private residence and was the home of the Annable family when this card was made. (Peabody Historical Society collection.)

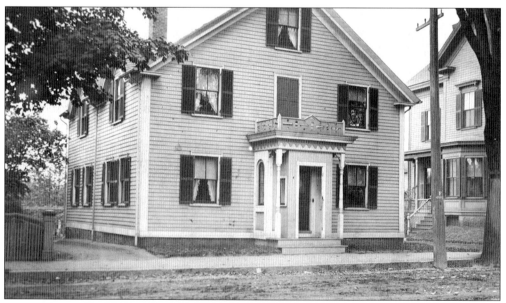

THE SCHOOLHOUSE. On this site was the first official schoolhouse in Peabody. Parts of this structure were built in 1713. This is where Katherine Daland began her public teaching career. (Peabody Historical Society collection.)

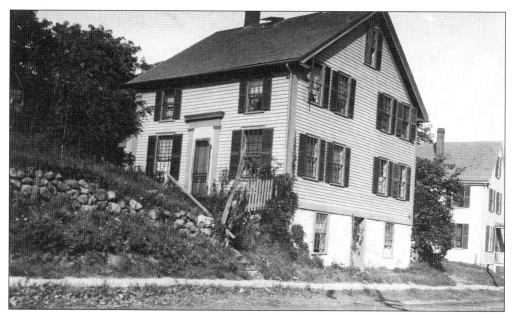

THE OLD SCHOOLHOUSE. Anecdotal evidence suggests that this house, still located on Tremont Street next to the Prescott Tomb, was originally part of the first public school in Peabody (Danvers). (Peabody Historical Society collection.)

A ONE-ROOM SCHOOLHOUSE. Thought to be located on County Street, this is another of the many one-room schoolhouses built under the old district school system in Peabody. (Peabody Historical Society collection.)

THE OLD STONE SCHOOLHOUSE, DISTRICT NO. 8. The school in District No. 8 was built in 1836 across from 119 Lynnfield Street. The second story was reputedly an addition placed on top of the original stone structure. The pumpkins in the foreground are from the Raddin farm, located in the area of today's Raddin Road and Raddin Park. Sadly, the Raddin Family Cemetery disappeared under a development in the 1980s. (Peabody Historical Society collection.)

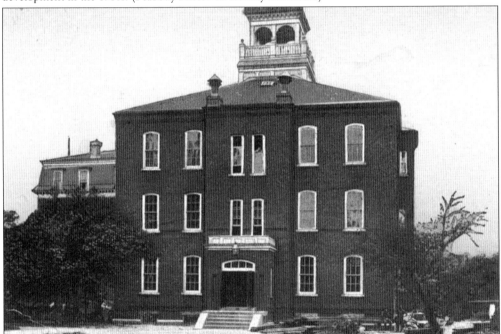

ST. JOHN'S GRAMMAR SCHOOL. The school shown here was built in 1916 as a replacement for the original school, built in 1893. On October 28, 1915, that structure caught fire while school was in session. The fire resulted in the deaths of 21 children. It was a truly tragic day in Peabody's history. (Peabody Historical Society collection.)

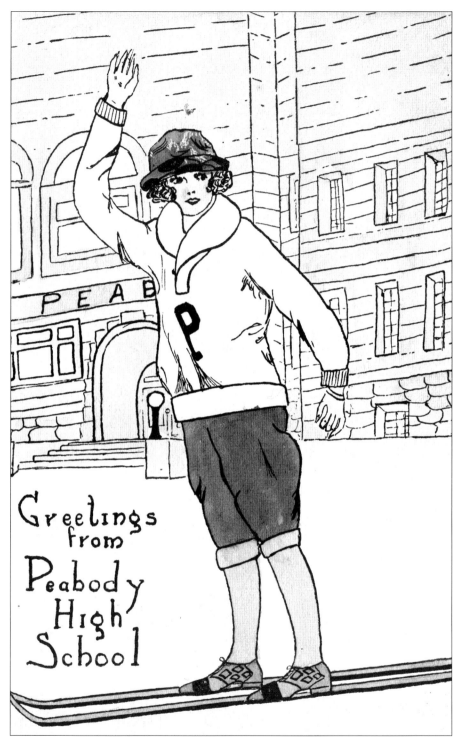

Greetings from Peabody High School

GREETINGS FROM PEABODY HIGH SCHOOL. This whimsical postcard shows a Peabody student wearing knickers and a letter sweater while skiing across the front lawn of Peabody High School. (Andy Metropolis collection.)

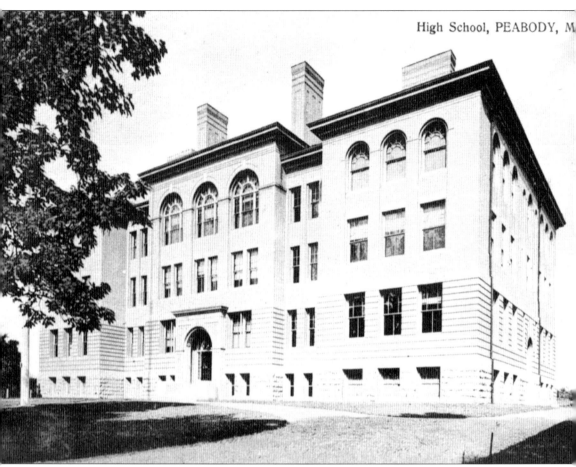

PEABODY HIGH SCHOOL. The following four postcards show the Peabody High School, a popular subject for photographers and postcard printers in the early 20th century. (Peabody Historical Society collection.)

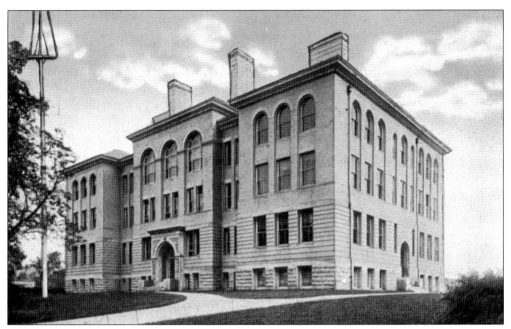

THE THIRD PEABODY HIGH SCHOOL. Completed in 1904, this building cost about $105,000. Contrast this with the projected cost of $80 million to build a new high school less than 100 years later. (Peabody Historical Society collection.)

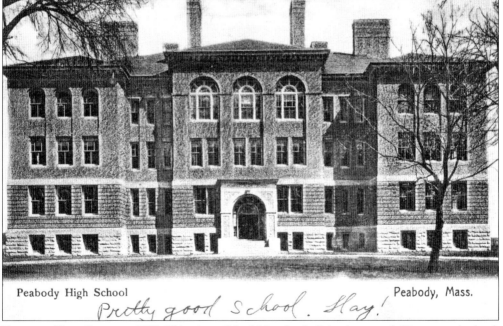

Peabody High School — Peabody, Mass.

Pretty good school. Hay!

PEABODY HIGH SCHOOL, 1909. This view of the high school elicits the remark "Pretty good school, Hay!" from Mildred McCarthy, of 42 Holten Street. She further writes to her friend Edith Higgins, in Littleton, New Hampshire, that she has met two girls and two fellows and that they plan to go to the Beverly beach the next day. (Peabody Historical Society collection.)

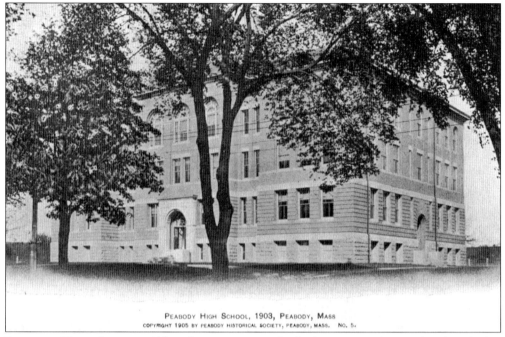

PEABODY HIGH SCHOOL, 1903, PEABODY, MASS
COPYRIGHT 1905 BY PEABODY HISTORICAL SOCIETY, PEABODY, MASS. NO. 5.

PEABODY HIGH SCHOOL. Although it was originally built to serve the needs of Peabody's schoolchildren for 50 years, the high school soon needed an an addition. Built in 1920, the additions eventually became the Seeglitz Junior High School. (Peabody Historical Society collection.)

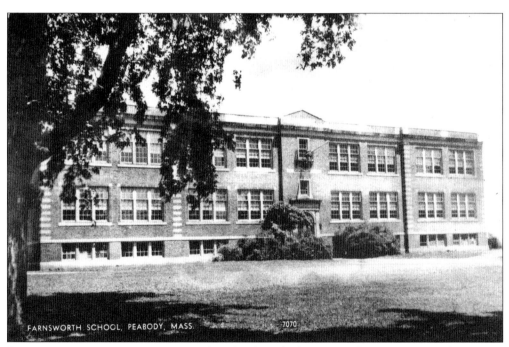

FARNSWORTH SCHOOL, PEABODY, MASS. 7070

FARNSWORTH ELEMENTARY SCHOOL. This school was built on Central Street in 1926. This site was once the Jacob Read farm. It is now used for elderly housing. (Dave Cronin collection.)

IN MEMORY OF
—— SAMUEL BROWN ——
BORN FEB. 16, 1836.

A NATIVE OF SOUTH DANVERS,
A GRADUATE OF HER PUBLIC SCHOOLS
AND BOWDOIN COLLEGE, CLASS OF 1858.

IN THE EARLY DAYS OF THE CIVIL WAR
HE ORGANIZED AND WAS COMMISSIONED
CAPTAIN CO. D-16TH CONN. VOLUNTEERS
AND WAS KILLED AT THE
BATTLE OF ANTIETAM
SEPT. 17, 1862.

A CITIZEN, SCHOOLMASTER AND SOLDIER
ADMIRED AND ESTEEMED.

THE PLAQUE ON THE BROWN SCHOOL. The Brown School, built in 1912, has been the elementary school to generations of South Peabody children. It was named for Capt. Samuel Brown, who was killed during the Civil War at the Battle of Antietam. (Peabody Historical Society collection.)

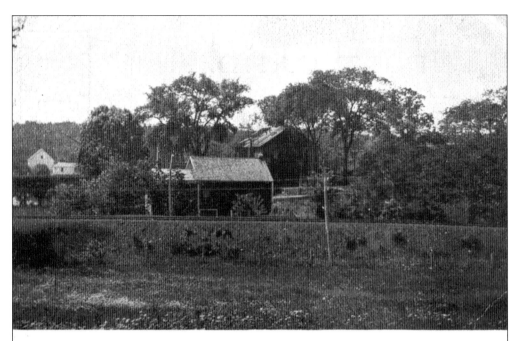

VIEW FROM PROSPECT STREET OF SALEM COUNTRY CLUB HOUSE, PROCTOR'S CROSSING, PEABODY, MASS.
AN OLD PROCTOR HOUSE BUILT 1805.

THE SALEM COUNTRY CLUB. In the late 19th century, golf was rapidly becoming popular with the upper class. There soon arose a need for a golf course in Peabody. In 1897, the first Salem Country Club was established on Lowell Street near Proctor's Crossing. It stretched back toward the present-day mall. This club disbanded in 1910. (Peabody Historical Society collection.)

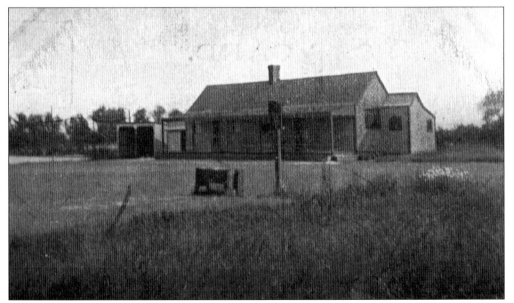

THE SALEM GOLF CLUB. The Salem Golf Club was founded in 1895 in the area of Gardner and Margin Streets. In 1925, the club moved to a brand-new 600-acre course on the Saunders farm, located on Forest Street. The club is now known as the Salem Country Club. (Peabody Historical Society collection.)

Eight
POINTS OF INTEREST

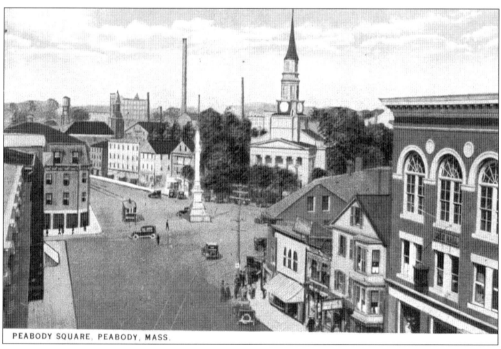

PEABODY SQUARE, PEABODY, MASS.

PEABODY SQUARE, PEABODY. In this stylized view from the 1920s, we can see the smokestacks of the A.C. Lawrence tannery in the background. The Forester's Hall is on the right next to Whidden's hardware. The South Congregational Church and the Soldiers and Sailors Monument dominate the square. (Peabody Historical Society collection.)

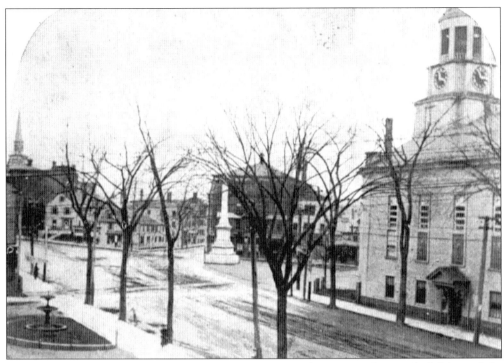

PEABODY SQUARE, 1890. In this rather dreary view, one lone figure is standing on the left beyond the fountain on Central Street. The steeple of the Baptist and Unitarian churches on Summer Street are on the left. (Peabody Historical Society collection.)

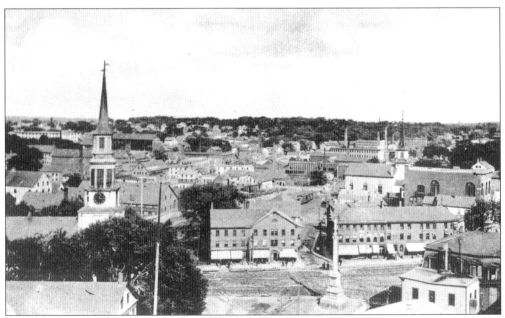

A PANORAMA OF PEABODY. This view of Peabody Square appears to have been taken from the cupola of the city hall. The tanneries along Walnut Street are visible. The Universalist church, backing up to Wallis and Mill Streets, can be seen behind the Allen Block. (Dave Cronin collection.)

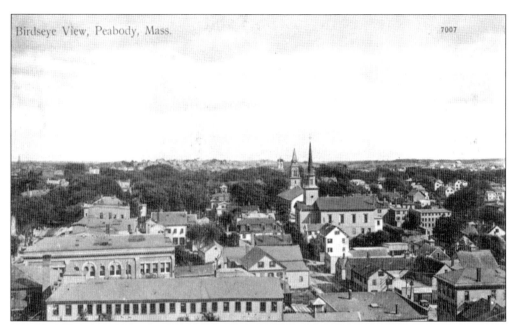

A Bird's-Eye View of Peabody, 1908. This scene of Foster and Winter Streets area also seems to be from the city hall. The top of the O'Shea Building No. 2 is on the left. The three churches are the Baptist church on Summer Street, the Universalist church on Park Street, and (in the distance) the steeple of the Methodist church on Washington Street. (Michael Schulze collection.)

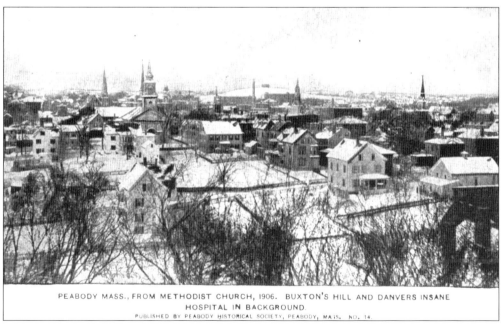

PEABODY MASS., FROM METHODIST CHURCH, 1906. BUXTON'S HILL AND DANVERS INSANE HOSPITAL IN BACKGROUND.
PUBLISHED BY PEABODY HISTORICAL SOCIETY, PEABODY, MASS. NO. 14.

A View from the Methodist Church. Taken from the steeple of the Methodist church on Washington Street, this photograph shows the area around Park, Summer, and Winter Streets. Next to the steeples on the left is the city hall. In the distance is Buxton's Hill, from which the next photograph was taken. The postcard advertises that the Danvers Insane Hospital is in the background. (Michael Schulze collection.)

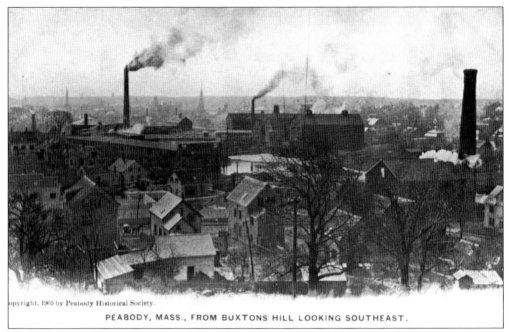

PEABODY, MASS., FROM BUXTONS HILL LOOKING SOUTHEAST.

PEABODY FROM BUXTON'S HILL, LOOKING SOUTHWEST. The houses in the foreground are on Endicott Street. The factory buildings of A.C. Lawrence leather tannery surround Crowninshield Pond. (Peabody Historical Society collection.)

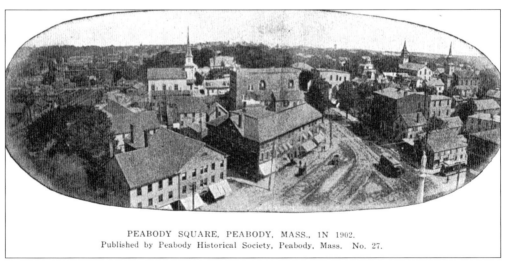

PEABODY SQUARE, PEABODY, MASS., IN 1902.
Published by Peabody Historical Society, Peabody, Mass. No. 27.

PEABODY SQUARE, 1902. Taken from the steeple of the South Congregational Church, this image shows the unpaved streets of Peabody Square, with two trolleys seemingly on a collision course at the corner of Foster Street and the square. (Peabody Historical Society collection.)

Nine

WEST PEABODY
AND ROUTE 1

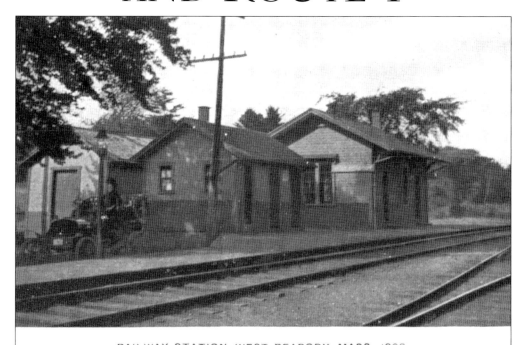

RAILWAY STATION, WEST PEABODY, MASS. 1906.
About 20 rods westerly from the junction, on the southerly side of the Salem and Lowell railroad, is site of house of Giles Corey, pressed to death in 1692, a witchcraft martyr.

THE WEST PEABODY RAIL STATION. Formerly located off Pine Street near the present-day trailer park, this station was an important rail junction where one could take trains to Lowell, Newburyport, and all points north. A passenger could also go south through Lynnfield Center, Wakefield Junction, and on to Boston. The sign reads, "West Peabody." Note the woman dressed in black in the car by the lamppost. (Peabody Historical Society collection.)

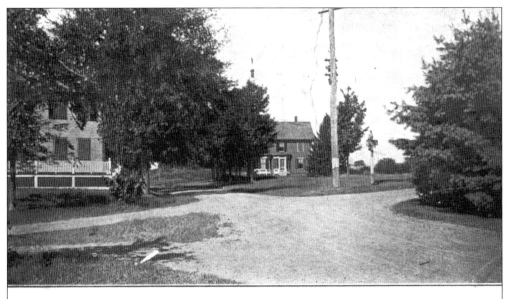

THE JUNCTION OF LOWELL AND NEWBURY STREETS, WEST PEABODY. Needham's Corner was located at the junction of Lowell and Newbury Streets. The Needham family was prominent in the area, owning a country store just off the highway. Route 1 runs from the left to the right of the picture. (Peabody Historical Society collection.)

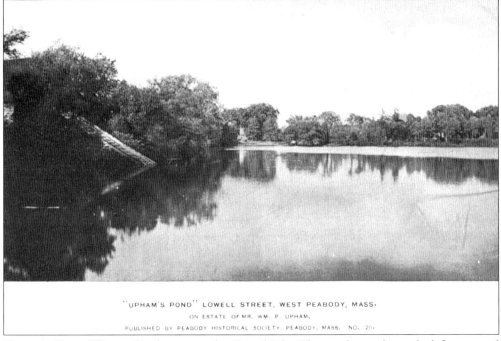

UPHAM'S POND. This pond is the present-day Crystal Lake. The wooden tracks on the left were used to haul blocks of ice up onto the shore. As with Brown's Pond in South Peabody, ice was cut in the winter months and stored for sale year-round. (Peabody Historical Society collection.)

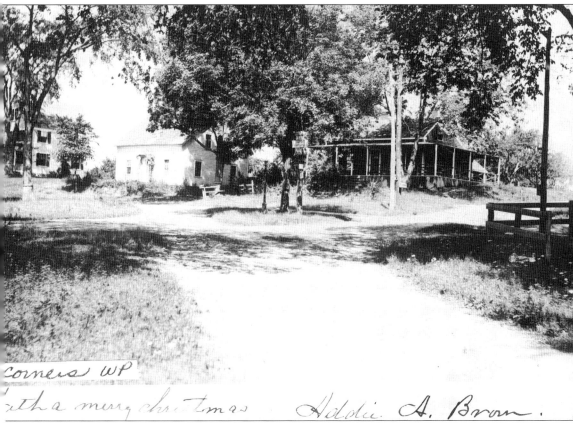

THE FOUR CORNERS: LAKE, WINONA, AND PINE STREETS. All three of the houses shown on Winona Street belonged to the Brown family. The homes are still in existence. This area of farms and woolen mills was known as Brookdale in the 19th century. (Peabody Historical Society collection.)

This was taken down by the dam

THE DEVIL'S DISHFUL. This view of the Devil's Dishful was taken from Lake Street. In the distance are the Brown homes on Winona Street. The pond is named after the character in a local folk tale about the devil visiting the area. (Peabody Historical Society collection.)

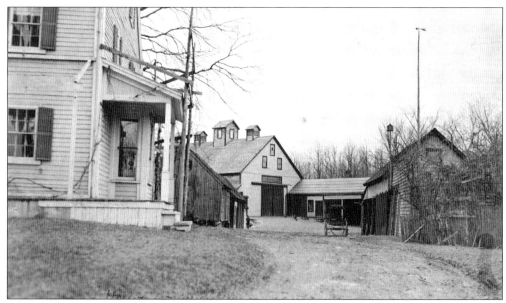

THE JOHN HERRICK FARM. The Herrick house and barn were located on the west end of Winona Street. The farm extended back toward Lowell Street and comprised the area today known as Herrick Estates. This house was destroyed by fire in 1948. (Peabody Historical Society collection.)

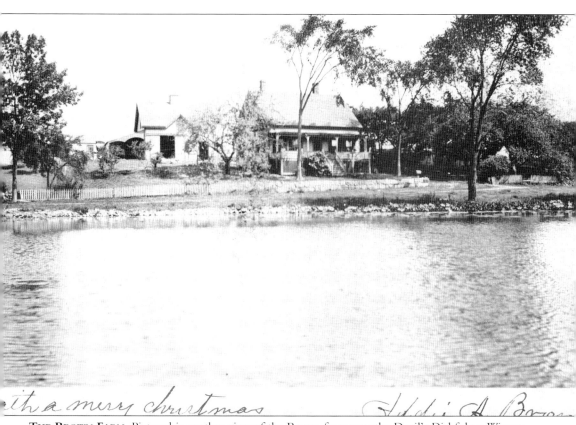

ith a merry christmas *Addie A. Brown*

THE BROWN FARM. Pictured is another view of the Brown farm near the Devil's Dishful on Winona Street. Addie A. Brown writes to Walter Brown in Vallejo, California, that his father had raised the house and added a cellar and the eight-foot piazza shown on the card. (Peabody Historical Society collection.)

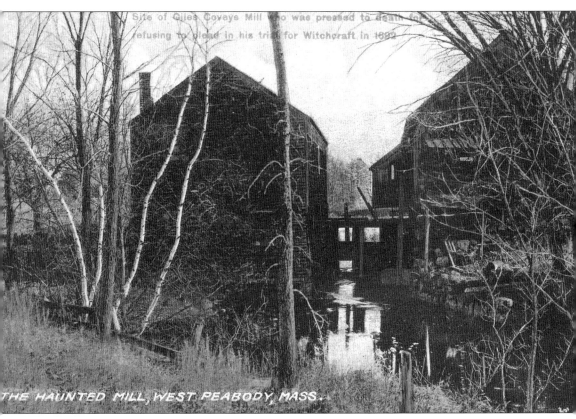

Site of Giles Coreys Mill who was pressed to death for refusing to plead in his trial for Witchcraft in 1692

THE HAUNTED MILL, WEST PEABODY, MASS.

THE HAUNTED MILL. The mill on this site once belonged to witchcraft martyrs Martha and Giles Corey. The foundation of the mill is still visible today at the outflow of Elginwood Pond near the corner of Lowell and Lake Streets. Giles was pressed to death by order of the court on September 19, 1692, and his ghost reputedly haunts the mill. Martha was hanged on charges of witchcraft just three days after her husband's death. (Dave Cronin collection.)

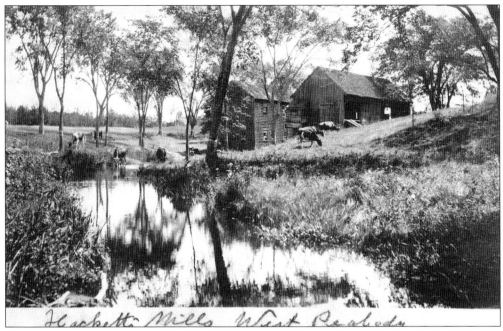

Hackett Mills West Peabody

HACKETT'S MILL, NEAR PHELP'S STATION, LOWELL STREET. Pictured here is an earlier view of the same mill. Phelp's Station was a stop on the Salem & Lowell Railroad. It was located behind the present-day site of the T.J. Maxx store on Lowell Street. (Dave Cronin collection.)

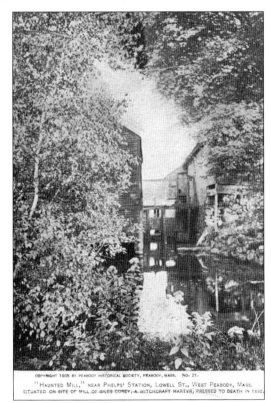

COPYRIGHT 1905 BY PEABODY HISTORICAL SOCIETY, PEABODY, MASS. NO. 21.

"HAUNTED MILL," NEAR PHELPS' STATION, LOWELL ST., WEST PEABODY, MASS.
SITUATED ON SITE OF MILL OF GILES COREY, A WITCHCRAFT MARTYR, PRESSED TO DEATH IN 1692.

THE HAUNTED MILL. This postcard is one of many that the nascent Peabody Historical Society printed to raise funds during its early years. This one is copyrighted in 1905, nine years after the society was founded. (Peabody Historical Society collection.)

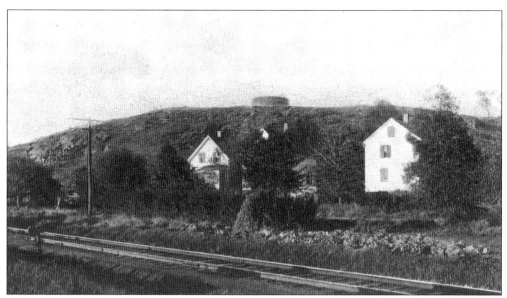

BUXTON'S HILL. This hill is composed of granite on its western end. Over the years, much of that hornblende has been quarried from the hill. In 1888, a reservoir holding 500,000 gallons of water was constructed on top of the hill to help satisfy the needs of the burgeoning town. (Michael Schulze collection.)

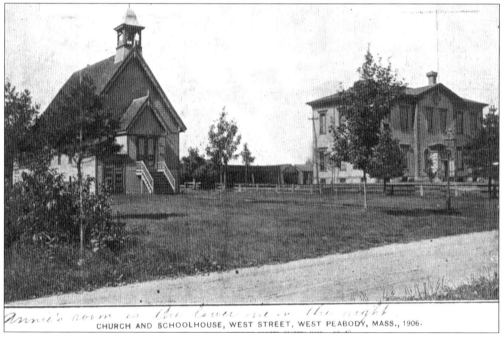

CHURCH AND SCHOOLHOUSE, WEST STREET, WEST PEABODY, MASS., 1906.

THE CHURCH AND SCHOOLHOUSE, WEST STREET, WEST PEABODY. In this view from 1906, we see the old West Congregational Church, built in 1885. This building was in use until 1961, when the present-day church was dedicated. The West School was built in 1870 to replace two smaller district schools located on Lowell Street. It was used as a school and community meeting place until 1957, when it was replaced by what is now known as the Kiley Brothers School. The current West School, located on Bow Street, was built in the 1950s. West street was renamed Johnson Street in honor of Howard Johnson, a World War II veteran. (Michael Schulze collection.)

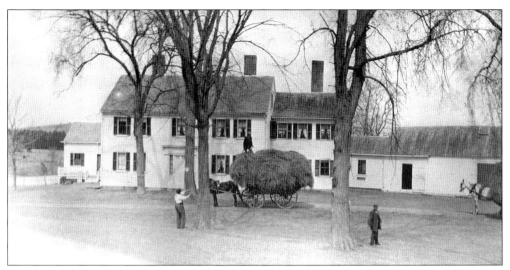

THE GEORGE HUTCHINSON FARM. Located on Russell Street near the Middleton line, this farm was originally part of the Russell farm. There are two Russell cemeteries still located nearby. The contents of a third were moved to Middleton in the early 20th century. In this 1907 picture, it appears to be haying season on the farm, with the wagon in the center loaded down with hay and another one coming into view. (Peabody Historical Society collection.)

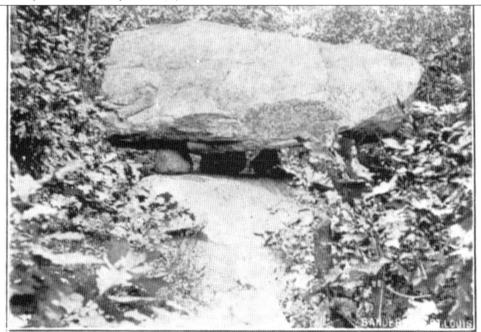

PHAETON ROCK, in Peabody. Mass., adjoining Lynn Woods. Deposited on the edge of a high precipice during the Glacial period.

PHAETON ROCK, SOUTH PEABODY. This large boulder was deposited by a glacier during the Ice Age. It came to rest on the edge of a precipice and is balanced on two smaller rocks. (Peabody Historical Society collection.)

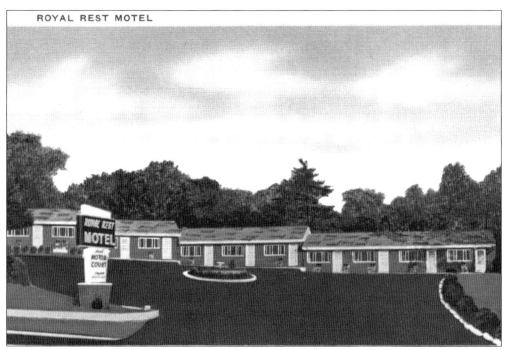

ROYAL REST MOTEL

THE ROYAL REST MOTEL. Located on the Newburyport Turnpike (Route 1), the Royal Rest was complete with television, air conditioning, and individual heat controls. (Michael Schulze collection.)

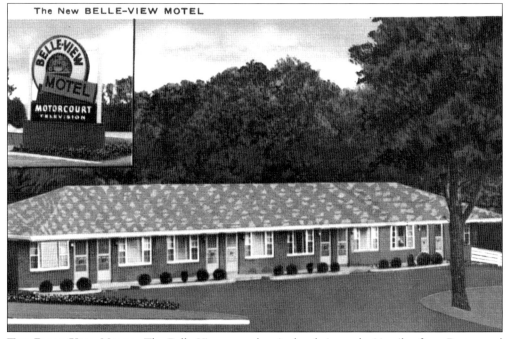

The New BELLE-VIEW MOTEL

THE BELLE VIEW MOTEL. The Belle View was advertised as being only 14 miles from Boston and convenient to North Shore beaches. It was demolished to make way for the Hampton Inn. (Michael Schulze collection.)

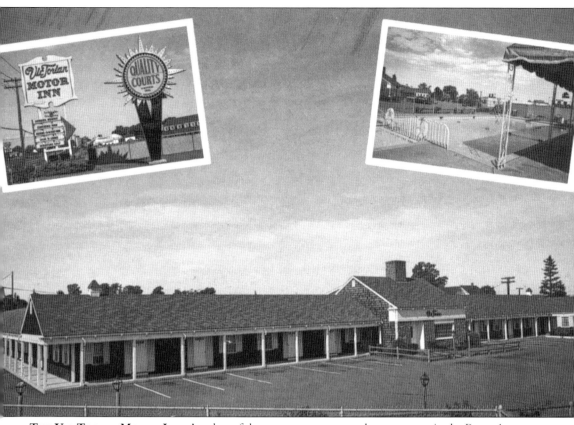

THE VIC TORIAN MOTOR INN. Another of the many motor courts that sprang up in the Route 1 area in the 1950s, the Vic Torian promised free miniature golf and a continental breakfast to their guests. (Michael Schulze collection.)

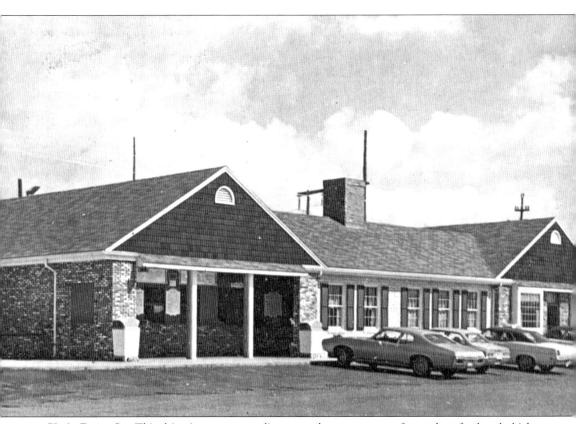

VIC'S DRIVE-IN. This drive-in restaurant adjacent to the motor court featured seafood and chicken dinners. The Sylvan Street Grille now occupies this site. (Michael Schulze collection.)

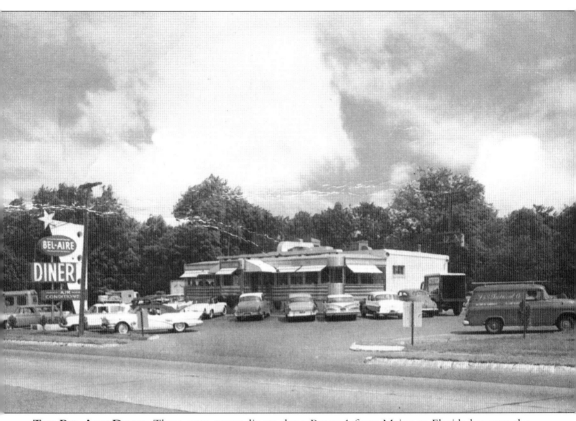

THE BEL-AIRE DINER. There were many diners along Route 1 from Maine to Florida between the 1940s and 1960s. The Bel-Aire was one such stop and is still serving travelers today on Route 1. (Dave Cronin collection.)

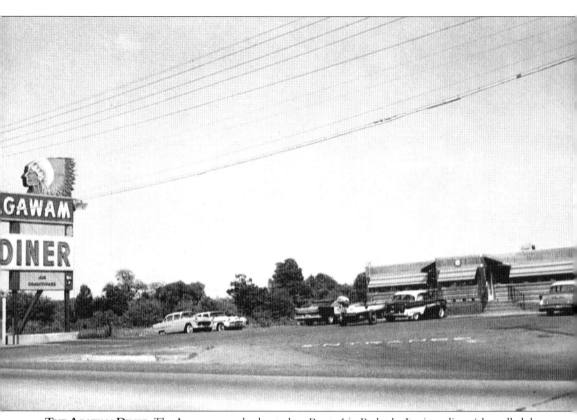

THE AGAWAM DINER. The Agawam was also located on Route 1 in Peabody. Its sister diner (also called the Agawam, located farther north on Route 1 in Ipswich) remains a popular stop. (Michael Schulze collection.)

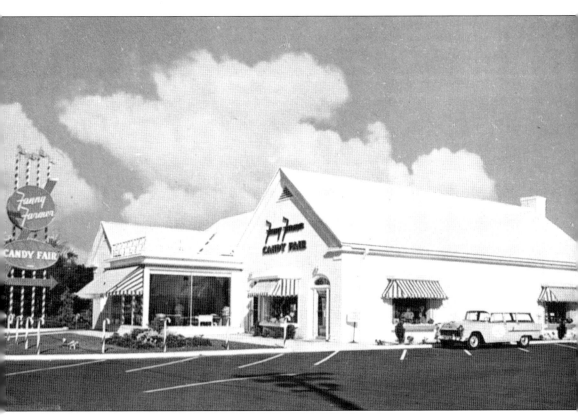

THE FANNY FARMER CANDY FAIR. This large shop on Route 1 was devoted almost exclusively to the manufacturing and sale of candy. Patrons were asked to "visit and see the finest foods from the world's richest markets blended into these delicious candies for your eating pleasure." (Michael Schulze collection.)

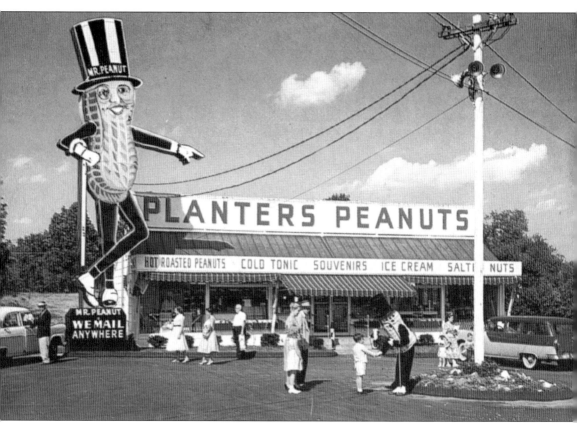

THE PLANTER'S PEANUTS STORE. "The Home of Mr. Peanut" roasted and sold the "world famous Planter's Peanuts before your eyes." After the store closed, the Mr. Peanut sign kept a lonely vigil on Route 1 for many years. (Michael Schulze collection.)

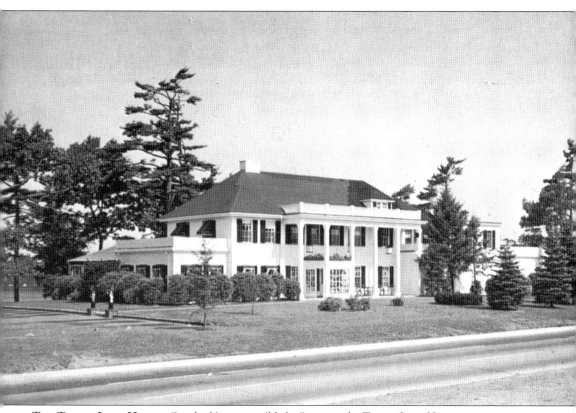

THE TOWNE LYNE HOUSE. Overlooking tranquil Lake Suntaug, the Towne Lyne House restaurant was one of the most popular restaurants on the pike for many years. It was recently razed to make way for Spinnelli's Bakery and Function Room. (Michael Schulze collection.)

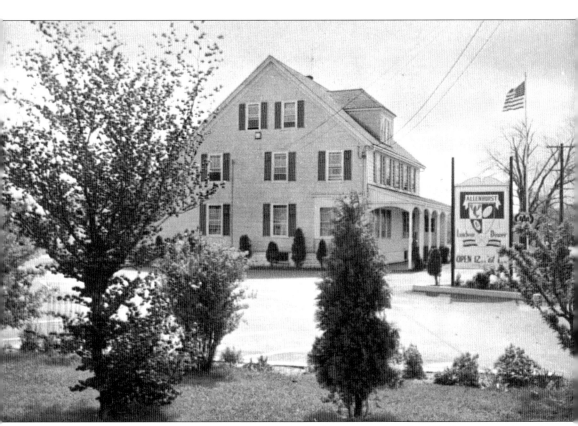

THE ALLENHURST RESTAURANT, DANVERS. The back of this postcard reads, "Allenhurst . . . is situated . . . in an area of fertile farms and charming homes—an area rich in the legends and lore of the town's proud colonial history." (Michael Schulze collection.)

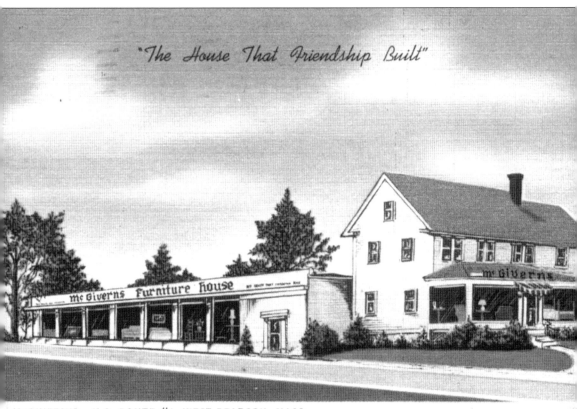

"The House That Friendship Built"

McGiverns Furniture House

McGiverns

McGIVERN'S - U.S. ROUTE #1, WEST PEABODY, MASS.

McGIVERN'S FURNITURE HOUSE. This store, located at the corner of Route 1 and Lowell Street, was one of the premier furniture stores in the area before a spectacular 1962 fire caused severe damage to the building. (Michael Schulze collection.)

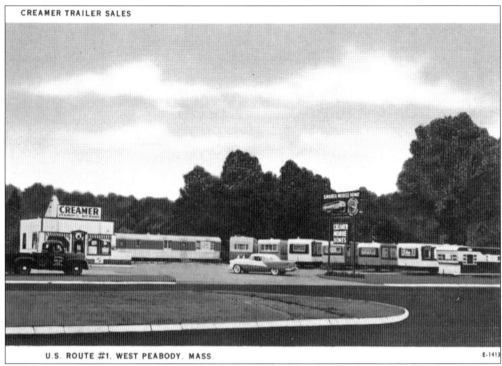

U.S. ROUTE #1, WEST PEABODY, MASS. E-1413

CREAMER TRAILER SALES. "Enjoy yourself—It's later than you think" was the motto of the Creamer Trailer Sales Company. Located in an area of Route 1 surrounded by mobile home parks, the Creamer lot was probably where many of the trailers were purchased. (Michael Schulze collection.)

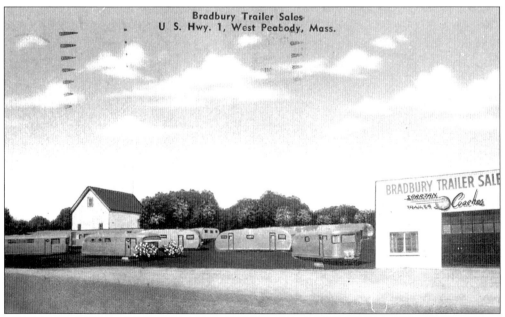

BRADBURY TRAILER SALES. Pictured is another trailer dealership on busy Route 1. This postcard was used in 1958 by Harold Heyland of Peabody to participate in a mail-in portion of *The Price Is Right.* (Michael Schulze collection.)

Ten

THE NORTHSHORE
SHOPPING CENTER

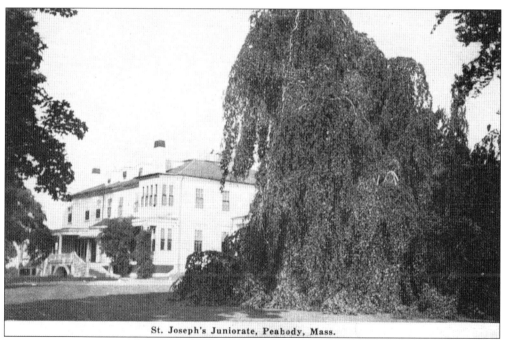

St. Joseph's Juniorate, Peabody, Mass.

ST. JOSEPH'S JUNIORATE. Once the estate of Jacob Rogers (a partner of J.P. Morgan), the Xaverian Brothers Juniorate covered most of what is today the Northshore Mall and Northshore Gardens. The site was sold to Allied Stores in 1954 for the construction of the Northshore Shopping Center. (Peabody Historical Society collection.)

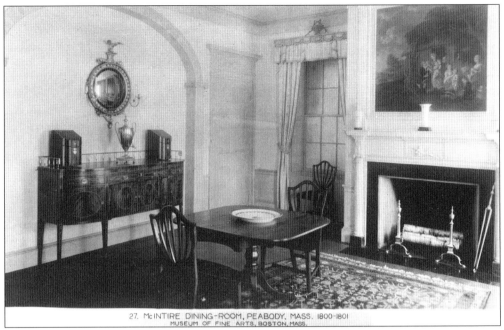

27. McINTIRE DINING-ROOM, PEABODY, MASS. 1800-1801
MUSEUM OF FINE ARTS, BOSTON, MASS.

THE McINTIRE DINING ROOM (ABOVE) AND PARLOR (BELOW) AT OAK HILL. When the Federal-style mansion of Oak Hill was razed, a number of the rooms containing woodwork created by the celebrated carver and master builder Samuel McIntire were moved to the Museum of Fine Arts in Boston. These following three scenes of the dining room, parlor, and bedroom are beautiful examples of American Federalist style. (Above Dave Cronin collection; below Michael Schulze collection.)

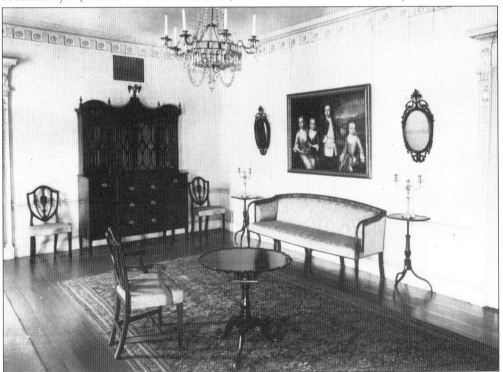

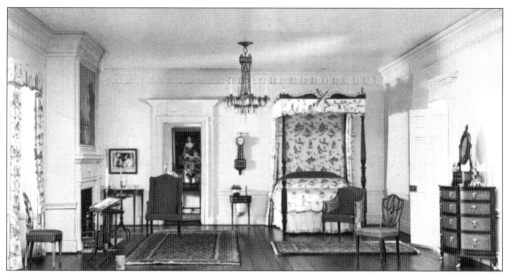

THE MCINTIRE BEDROOM AT OAK HILL. (Above Dave Cronin collection; below Michael Schulze collection.)

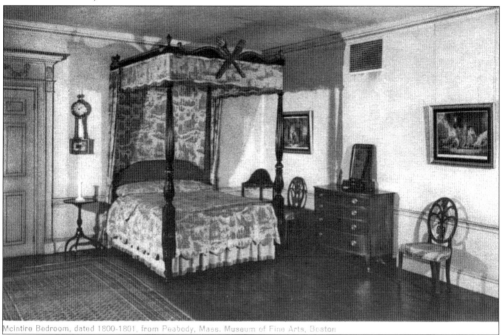

McIntire Bedroom, dated 1800-1801, from Peabody, Mass. Museum of Fine Arts, Boston

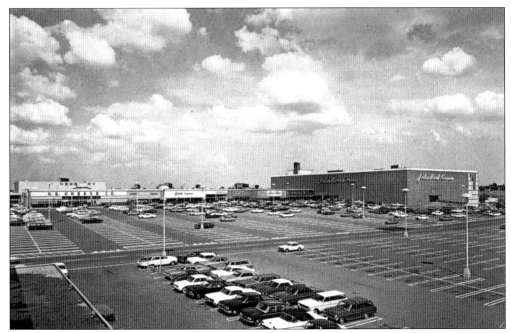

THE NORTHSHORE SHOPPING CENTER. Now known as the Northshore Mall, the shopping center was among the largest malls in the country when it opened in 1958. It forever changed the shopping habits of the citizens of the neighboring areas but had a deleterious effect on downtown business. The mall has grown many times larger and is the retail center of the North Shore. (Above Dave Cronin collection; below Michael Schulze collection.)

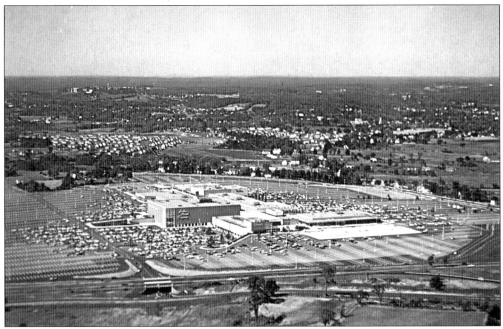

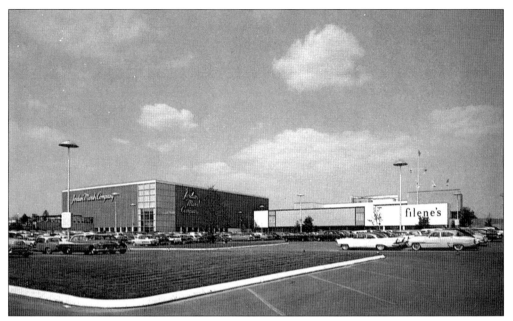

JORDAN MARSH AND FILENE'S. These two stores were the anchors of the "fabulous new Shopping Center at the Junction of Routes 128 and 114," as described on the back of this postcard. (Michael Schulze collection.)

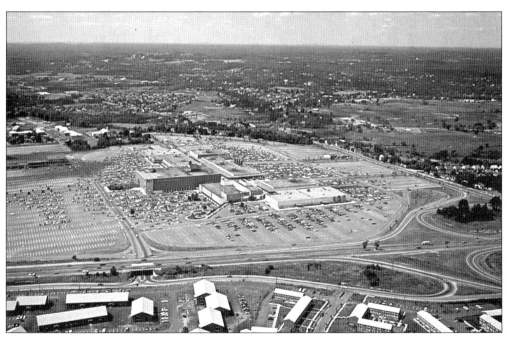

AN AERIAL VIEW OF THE NORTHSHORE SHOPPING CENTER. In this 1960 view, note how few cars are traveling on Route 128. In the foreground are the gleaming white roofs of the new Terrace Estates. In the distance on the far right is the farmland where the Liberty Tree Mall in Danvers is now located. (Michael Schulze collection.)

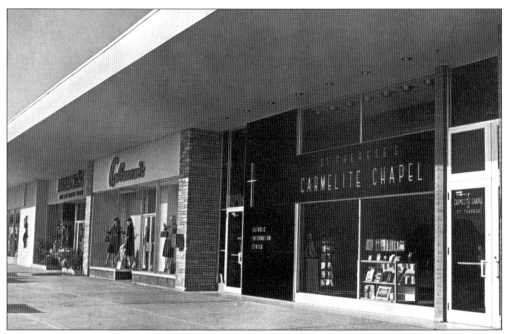

THE CARMELITE CHAPEL IN THE NORTHSHORE SHOPPING CENTER. The back of the postcard tells us that this an attempt by the Carmelite Order of St. Therese to bring Christ to the marketplace. This has proven to be a successful campaign, since the chapel has survived and prospered for more than 40 years. (Michael Schulze collection.)

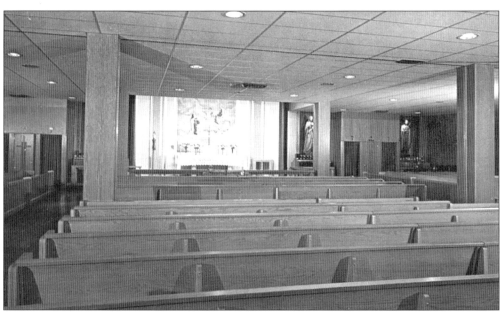

THE INTERIOR OF THE CARMELITE CHAPEL. The "shopper's chapel" can accommodate 450 worshippers. In addition to the chapel, the staff offers a gift shop, library, information center, and conference rooms. (Michael Schulze collection.)

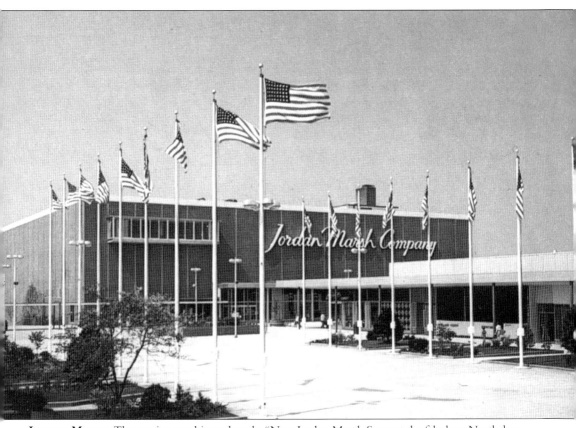

JORDAN MARSH. The caption on this card reads, "New Jordan Marsh Store at the fabulous Northshore Shopping Center." Although recently converted to Macy's, Jordan Marsh was once one of the premiere shopping destinations in New England. (Michael Schulze collection.)

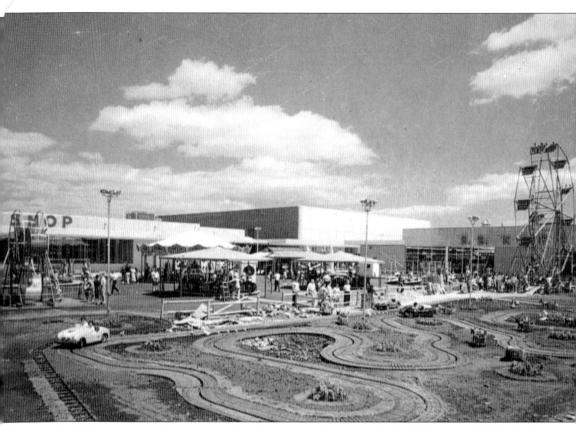

THE NORTHSHORE MALL. In this early view of the mall, we can see in the foreground Kidee Land, a small amusement park that proved quite a draw for family shoppers. On the right is an early competitor of F.W. Woolworth—S.S. Kresge, which went on to become the K-Mart of today. On the left is the Stop & Shop grocery store. (Michael Schulze collection.)